IMAGES
of America

DAUFUSKIE
ISLAND

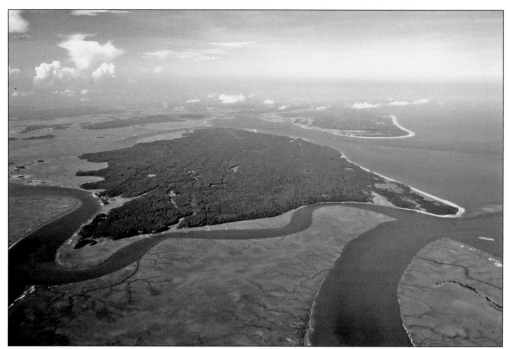

This aerial view of Daufuskie Island was taken during an archaeological study at Haig Point in 1985. Looking northeast, the sandy shore at the lower right is Bloody Point, the island's southeastern tip and the southernmost point of South Carolina. Turtle Island, the New River, a thriving expanse of salt marsh, and Mungen Creek are in the foreground. Hilton Head Island can be seen at the upper right. Daufuskie is approximately five miles long and two and a half miles wide and comprises approximately 5,000 acres. (Larry Lepionka.)

ON THE COVER: A young boy helps Franklin Miller carry a washtub full of blue crabs at the public landing at Benjie's Point on Daufuskie Island, South Carolina. They were photographed by Constantine Manos, the 18-year-old son of Greek immigrants living in Columbia, who, in 1952, hitched a ride in a crabber's boat from Bluffton with his new camera and several rolls of film. Warmly embraced by the island community, he was welcomed into homes, the Mary Field School, the First Union African Baptist Church, Captain Stevens's nightclub, and Sheppard's Luck store. Manos's collection of images may be the only visual record of life on Daufuskie in the 1950s. (Constantine Manos.)

IMAGES
of America

DAUFUSKIE
ISLAND

Jenny Hersch and Sallie Ann Robinson

ARCADIA
PUBLISHING

Copyright © 2018 by Jenny Hersch and Sallie Ann Robinson
ISBN 978-1-4671-2768-4

Published by Arcadia Publishing
Charleston, South Carolina

Printed in the United States of America

Library of Congress Control Number: 2017942438

For all general information, please contact Arcadia Publishing:
Telephone 843-853-2070
Fax 843-853-0044
E-mail sales@arcadiapublishing.com
For customer service and orders:
Toll-Free 1-888-313-2665

Visit us on the Internet at www.arcadiapublishing.com

CONTENTS

ACKNOWLEDGMENTS

Many thanks to Adam Hersch, Stephen Hoffius, Emory Campbell, Ella Mae Jenkins, Dr. Lawrence Rowland, Rev. James Curtis Hudson, Isabelle Hudson, Lancy and Emily Burn, Gene Burn, Cleve Bryan, Thomas Stafford Jr., Abraham Miller, Constantine Manos and Michael Prodanou, Jeanne Moutoussamy-Ashe, Bruce Davidson, Meagan Connolly, Carol Hill Albert, Pete Marovich, Eric Horan, David Morrison, Zachary Sklar, Billy and Paul Keyserling, Martha Hutton, Beth Finnegan, Christina Roth Bates, Tucker Bates, Catherine Campbell, Sally Lesesne, Toni Beavor, Adam Martin, Beth Shipman, Michael and Joanne Loftus, Larry Lepionka, Fran Bollin, Wick Scurry, Meg Bartlett, Roger Pinckney XI, Wendy Nelthorpe, Nadia Wagner, James and Carol Alberto, Dr. John Herman Blake, Bill Boyd, Paul Johnson, Christopher Holmes, Woody Collins, Bev Jennings, Roland Gardner, Jake Washington Jr., Jake Washington III, Margarite Washington, Kenneth "Kenny Mack" Johnson, Gerald Yarborough, Terri Painter, Sylvia Wampler, Dan Stoddard, Leonora Stoddard Courtland, Beverley Stoddard Koch, Janet Adams, Joie Lee, Amanda Powers Hersch, Melissa Davis, John Hill, Kathy Wagoner, Ann Foskey, and Natalie Hefter.

This book would not be possible without the work of Billie Burn and Rebecca Starr. Their research, interviews, collected photographs, and historical documents form the basis of the Daufuskie Island Historical Foundation archives, an invaluable resource.

Thanks also to Michael Bedenbaugh at Preservation South Carolina, Grace Cordial at the Beaufort County Library, Allison Dillard and Lynette Stroud at the Georgia Historical Society, Jessica Crouch at the University of South Carolina Rare Books and Special Collections, Steven Tuttle at the South Carolina Department of Archives and History, Sarah Earle at the University of South Carolina Library, Aaisha Haykal at the Avery Research Center for African American History and Culture at the College of Charleston, Kathy Shoemaker at the Rose Library at Emory University, Hannah Spencer and Thomas Lingner at the Harvard College Library, Carla J. Reczek at the Detroit Public Library, Renee Pappous at the Rockefeller Archive Center, trustees of the Daufuskie Island Historical Foundation (Eileen Pojednic, Toni Ferguson, Geoff Brunning, Leanne Coulter, Sara Deitch, Andy Mason, Jo Hill, and Nancy Ludtke), and to Ashley Harris, Leigh Scott, Sarah Gottlieb, Steve Sawyer, Liz Gurley, and David Mandel at Arcadia Publishing, for the opportunity to share this story.

INTRODUCTION

Daufuskie, one of more than 100 sea islands off the southeast Atlantic coast, has inspired artists, intrigued archaeologists, and enticed developers. Approximately 400 people make Daufuskie their primary residence. Only seven extended families currently live on the island who are descendants of enslaved Africans who, from the mid-1700s through 1861, cut trees, cleared fields, built roads, dug drainage ditches, planted and picked indigo and cotton, tended livestock, tanned hides, cured meat, made lard and honey, and kept house for their often-absent owners. These descendants, some living on ancestral property, have a connection to their past through language and foodways that has made their way of life a curiosity to visitors. Today, cultural-heritage tourism, ecotourism, and the residential service industry have replaced agriculture, mariculture, and logging as the economic drivers on the island.

In the 1520s, when the Spanish and French were exploring what is now South Carolina and Georgia, the earliest European colonies were established in territories inhabited by native peoples. In the 1660s, the British began expanding their range of settlements southward. In 1701, they established a post on Daufuskie to guard against Spanish and native raids. By 1707, the British had staked their claim to the island and granted well over 1,000 acres of land to their countrymen who as Indian traders exchanged trade goods for animal pelts and hides for export overseas. Though illegal, there was also a market for native slaves in the British colonies regionally and in the West Indies. Years of clashes between British colonial forces and displaced native peoples ensued, including several well-documented assaults on Daufuskie. The log-walled Passage Fort was built in 1717 at the site of the 1701 guard post. In 1728, one particular beachfront battle left an indelible mark on the island, at the site that became known as Bloody Point.

From 1733 through 1735, George Haig, a Scottish merchant, land speculator, and Indian trader, purchased more than 1,000 acres at the north end of Daufuskie. Indigo farmer Thomas Parmentor (d. 1769) relocated to Daufuskie from Port Royal Island in the mid-1750s with his wife, Dorothy, and daughter Sarah. Also from Port Royal, the recently widowed Mary Foster Martinangele bought 500 acres (Dunn and Eigelberger Plantations) and moved to Daufuskie in 1762 with her eight children, 12 enslaved Africans, 25 sheep, five head of cattle, two horses, and several small boats. The Revolutionary War earned Daufuskie the nickname "Little Bermuda" for its Loyalist leanings with Philip Martinangele Jr. (d. 1781), son of Mary Foster Martinangele, as captain of the island's British Royal Militia. Haig (Haig's) Point passed through three generations of the Haig family until 1810 when the land was sold to John David Mongin (1763–1833) and Sarah Watts Mongin (d. 1816), likely for their son David John Mongin (1791–1823).

By 1820, cotton had become the primary agricultural commodity on Daufuskie, substantially increasing the profitability of the improved acreage. Additional enslaved Africans were bought to provide the labor for this expansion. In 1822, northern missionaries Jeremiah Evarts and Chauncy Eddy visited Daufuskie and stayed at the Bloody Point home of David John Mongin. Evarts noted in his diary the disparity between the lives of the white slave owners and the enslaved Africans:

"I have resided now three days on a sea-island plantation, where I was treated with all the hospitality, which the owner was master of. The house was large, rooms airy, the furniture costly, the provisions of the table profusely abundant. . . . The master of the house was incapable of society

from drinking brandy, and consequent stupidity and ignorance. He had been educated at Princeton College, and is probably somewhat under 40. Every evening is so far overcome with strong drink, as to be silly, every morning, full of pain, languor, and destitute of appetite. The state of the slaves, as physical, intellectual, and moral being [sic], is beyond my powers of description: yet the state of the master is more to be pitied, as it exposes him to a more aggravated condemnation."

Evarts was startled by the harsh circumstance of those enslaved. He wrote, "The situation of the slaves is more abject and degraded than I ever supposed," noting that "the fare of plantation slaves is coarse and scanty." Evarts was particularly concerned for the elderly. "Their poor bodies appear to be worn out, by hard services."

By 1833, the Mongins owned more than 4,000 acres (approximately 80 percent of Daufuskie Island), including Bloody Point, Oak Ridge, Eigelberger, Melrose, Maryfield, Cooper River, Haig Point, and Freeport Plantations. More than 2,000 acres were being cultivated by more than 200 enslaved Africans serving the economic interests of the Mongins and, soon after, the Stoddard family. The Dunn property prospered with approximately 20 enslaved Africans working the land and caring for the house.

The Confiscation Act of 1861 led to the occupation of Daufuskie Island by Union soldiers. The abandoned houses at Melrose and Bloody Point and the two-story cotton gin on the Dunn property were left intact while other structures were scavenged or burned. Sometime after 1864, freed slaves arrived on the island and by 1884, they had purchased or were deeded more than 100 parcels of between two and 15 acres on the Cooper River, Maryfield, Benjie's Point, and Dunn properties. They survived on the crops they could grow, animals they could hunt, and seafood they could catch.

In 1865, former slaveholding families began returning to the island from Savannah after redeeming their land through payment of taxes and fines. By the early 1870s, a small number of white families moved to Daufuskie as sharecroppers, while others found work as merchants and lighthouse keepers. State-specific Black Codes and Jim Crow laws separated black and white schoolchildren. The two island churches (built in 1881 and 1901) had black congregations. With jobs created by the flourishing oyster and timber industries, the island population peaked at almost 700 from the 1910s through the 1930s. In 1940, Daufuskie had a population of 550 that dropped to 370 in 1950. Changes in the island's economy and opportunities for education and employment drew several generations away from Daufuskie—particularly to Savannah. While many families retained their homes and ancestral lands, some young children were left to be raised on the island by their grandparents. In 1966, the island population dropped to 120, with 55 adults and 65 children.

While the island community was not immune to racial discrimination and animosity, no evidence of segregation on the ferries or in the general stores has been found. With the absence of public facilities, other than the schools, there were no discernible signs of compulsory separation by race—though some relationships were based on tolerance, not necessarily trust. In 1962, during the civil rights movement, the last white student on the island graduated from the Daufuskie School, built for white students in 1913, leaving the Mary Field School, built for black students in 1934, as the island's only active school. In 1969, Pat Conroy became the Mary Field School's first white teacher, integrating the staff, and in 1981, the student body was integrated with the enrollment of four white students. The population rose to 138 residents in 1971, then dropped to 90 residents in 1980, with fewer than 60 residents by 1982.

Daufuskie's large tracts at Bloody Point, Eigelberger, Webb, Haig Point, Melrose, and Oak Ridge were overgrown and had been virtually uninhabited for decades. Because the owners were absent, the land was often used by island residents for hunting; fishing; harvesting of fruit trees, nuts, and berries; and grazing of cattle. When corporate development began in the mid-1980s, the land that had appeared open and available was posted as private property. Longtime residents, both black and white, worried about the impact of development on what is now known as the Historic District (property located at Benjie's Point and in the former Cooper River, Maryfield, and Dunn Plantations) and on the island as a whole.

Haig Point, Melrose, and Bloody Point were developed as residential and resort communities from the mid-1980s through the early 1990s, leaving Oak Ridge, Eigelberger, and the Webb Tract forested. Concerned for the vulnerability of ancestral land in the Historic District, conflicts arose in the early 1990s between a group of Daufuskie's black residents, developers, and Beaufort County. Representatives from the Christic Institute South and the National Association for the Advancement of Colored People (NAACP) were called upon to assure that ancestral land was not unfairly infringed upon, property taxes were proportionally assessed, and public services were adequately provided.

In 2003, the National Park Service published a draft of its *Low Country Gullah Culture Special Resource Study*, noting, "The sea islanders of today are threatened by the ever-increasing pace of modern life with its economic demands. They are not a museum piece, relics of the past, but rather survivors of enslavement, bondage, discrimination, and white privilege—fellow human beings entitled to work out their own destiny. Hopefully the best of sea island life, language, customs, and values can be preserved, even as the people take advantage of new opportunities and move into mainstream America."

Today, much of the island looks and sounds as it did in the 1950s, 1960s, and 1970s, even though, in 1984, Beaufort County planners predicted that 10,600 people would be living on Daufuskie by the year 2000. Clusters of now hundred-year-old homes, some with horses and dogs in the yard, are surrounded by vast woodlands. Restored historic structures, including churches and schools, and many newly constructed homes, dot the dirt roads that are protected by dynamic salt marshes, dunes, and pristine beaches. Nights are truly dark, and the island is quiet but for the hum of golf carts, the rumble of the occasional truck, or the squawk of a heron, egret, osprey, wood stork or bald eagle.

People who live on Daufuskie, regardless of when they arrived or the neighborhood where they choose to live, are self-reliant, resilient, and through the unique aspects of island life, share a common bond.

One

1800s

During the 1800s, plantation owners traveled regularly between their residences on Daufuskie and in Savannah, spending extended periods off-island. Cotton drove the plantation economy with wheat, corn, tobacco, sugar cane, and sweet potatoes, also grown on the improved acreage. The number of enslaved Africans bought and slave dwellings built directly correlated with the income produced from the property.

In January 1862, two months after the Battle of Port Royal, Union soldiers from New York, Massachusetts, New Hampshire, Maine, and Connecticut camped at the Cooper River and Dunn Plantations, confiscated property, and enforced the evacuation of the island. To build a wharf on the New River and cannoned-batteries on Jones and Bird Islands, more than 10,000 trees were cut and hauled from the woods. In April 1865, at the end of the Civil War, Daufuskie plantations were sold at auction at the Port Royal House hotel on Hilton Head Island by the US District Tax Commissioners. After payment of fines and outstanding taxes, owners reclaimed all properties but the Dunn and Webb tracts. Between 1864 and 1867, teachers from the American Missionary Association were sent from Pennsylvania and Massachusetts to teach the island's children. A field report from the Bureau of Refugees, Freedmen and Abandoned Lands listed 10 families (32 adults and 11 children) staying at Haig Point in 1866, who likely lived in the former tabby slave dwellings by the Cooper River.

An 1871 Act of Congress called for two lighthouses to be built on Daufuskie to guide ships from the Atlantic Ocean through the Calibogue Sound. In 1873, Mary Dunn redeemed her Prospect Hill property, and in 1875, a portion of the Webb Tract was sold by the government to William D. Brown. Between 1872 and 1884, the Dunn, Maryfield, Benjie's Point, and Cooper River Plantations, with the exclusion of four acres on the Dunn property reserved for the family cemetery, were divided into more than 150 lots, today's Historic District. Many of these parcels were sold or transferred to freed slaves, including 12.2 acres given to Toby Holmes (b. 1850) in 1884 by Henry Mongin Stoddard (1846–1905). Daufuskie Island's First Union African Baptist Church was built in 1881. In 1892, the federal government appointed James Peto Chaplain Jr. as Daufuskie's first postmaster. For five weeks in 1899, a quarantine detention camp was established at Bloody Point for soldiers and civilians returning from Cuba after the Spanish-American War.

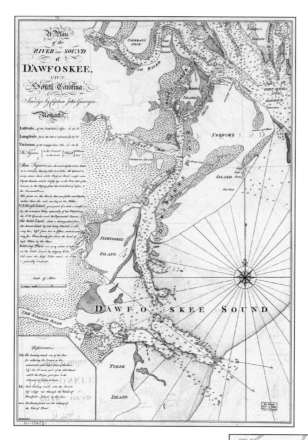

Based on Capt. John Gascoigne's nautical surveys (1729–1734), this map of "D'awfoskee" was first printed in 1776 as an aid for navigation during the American Revolution. Observations and measurements, including depths, oyster banks, marsh, solid land, and watering places, were made by Captain Gascoigne and his brother Lt. James Gascoigne of the HMS *Aldborough*. Today, "D'awfoskee Sound" is the Calibogue Sound, and "D'awfoskee Creek" is the Cooper River to the west and Mungen Creek to the south. (Library of Congress.)

There were no paved roads or street signs on Daufuskie in 1959 when this map was made by the South Carolina Department of Transportation. After the Civil War, clusters of houses were built by freed slaves and their descendants in neighborhoods called "Cooper River," located along the Cooper River; "Benjie's Point," on the New River, named for Benjamin Green (d. 1865), who in 1860 married Isabelle Stoddard (1840–1927), owner of Benjie's Point Plantation; and "the Branch," named for a secondary line of the timber industry's temporary railway. The Mary Field School is misidentified as the Daufuskie School. (South Carolina Department of Transportation.)

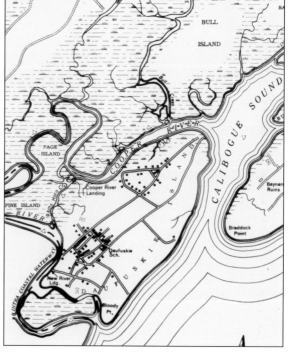

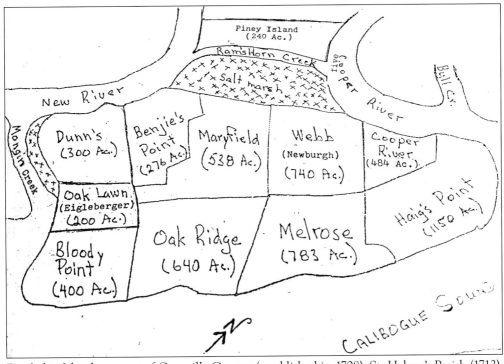

Daufuskie Island was part of Granville County (established in 1708), St. Helena's Parish (1712), and St. Luke's Parish (1767). In 1768, the original counties were eliminated. In 1769, seven districts were created including the Beaufort District. In 1785, the Beaufort District was divided into four counties that were abolished in 1798. In 1868, the Beaufort District was renamed Beaufort County. The map above, drawn by Albert Henry Stoddard Jr. (1872–1954), depicts the plantations of Daufuskie Island and their acreage in 1862. Today, Haig Point, Melrose, and Bloody Point are developed. The Oak Ridge, Eigelberger, and Webb properties also remain intact, and all have retained the original plantation names. Below is a street map of Daufuskie created in 2009. (Above, Daufuskie Island Historical Foundation; below, John Hill.)

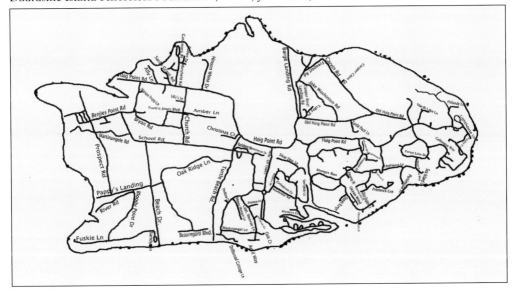

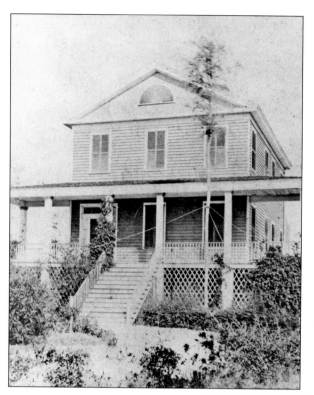

By the late 1700s, the Martinangele family owned this 200-acre property on Mungen Creek, which Christian Eigelberger (1781–1831) acquired by 1810. When he died with no heirs, the Eigelberger Tract was purchased in 1831 by John David Mongin, who then owned Cooper River, Haig Point, Freeport, Melrose, Oak Ridge, Bloody Point, and Maryfield Plantations. John Irving Stoddard (1843–1924) inherited the property in 1868. He lived in the house (likely built in the 1760s for Mary Foster Martinangele) when this photograph was taken in 1874. A barn and a 12-hole outhouse survived until the early 1920s, and in 1994, an archaeological study unearthed the remains of four slave cabins. (Lancy and Emily Burn.)

This rustic gazebo on the Eigelberger Tract on Mungen Creek, seen here in 1888, was adorned with "knees" from nearby cypress trees. Christian Eigelberger was born in 1781 in Newberry County, South Carolina, to German immigrant parents. While living alone on Daufuskie, Eigleberger owned two slaves in 1810, then 31 in 1820, and 42 in 1830, the year before his death. In 1819, he placed an ad in the Savannah *Republican* newspaper offering a reward for the return of an enslaved woman: "Mary is about 5 feet high, stout made, and speaks French. Ten dollars will be paid for lodging her in Savannah jail, or twenty dollars if proven to be harbored by any person." (Lancy and Emily Burn.)

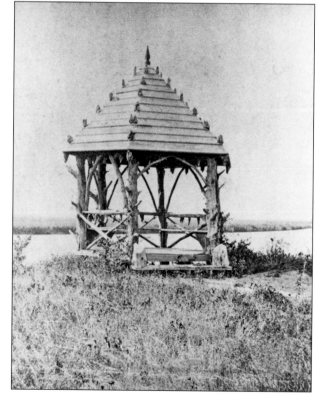

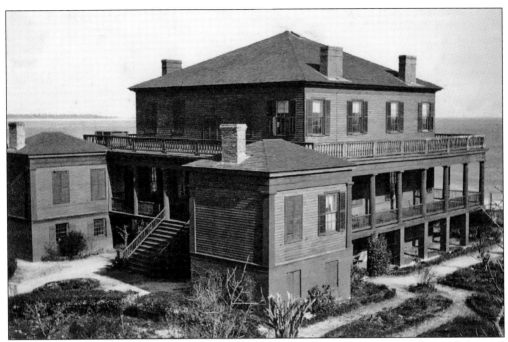

Completed by 1845, the mansion at Melrose Plantation (once known as Salt Pond) housed generations of Mongins, who first arrived on Daufuskie in 1783 after the marriage of William Edwards Mongin (1749–1814) and Margaret Martinangele (1755–1806), and the Stoddards, who arrived in 1837 following the 1836 marriage of John Stoddard II (1809–1879) and Mary Lavinia Mongin Stoddard (1819–1865). In 1866, the Stoddards returned to Daufuskie from Savannah after a five-year absence. Former slaves leased land, worked as sharecroppers, or worked for hire in the fields and orchards. This photograph was taken before the devastating sea island cyclone of 1893. (Wick Scurry.)

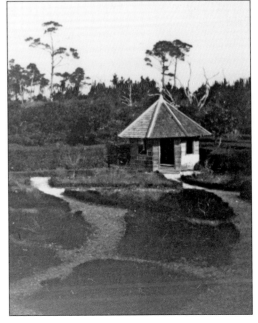

Hired by John Stoddard II and Mary Lavinia Mongin Stoddard, James Henderson (1818–1857) designed and planted the elaborate Melrose gardens and built their summer house (gazebo) between 1845 and 1847. Henderson came to the United States from Scotland, where he had been a gardener's apprentice. In 1947, he and his younger brother Peter (1822–1890) founded successful horticultural businesses in New Jersey. "In all my life I never saw such a beautiful place," wrote American Missionary Association teacher Eliza Ann Summers in 1867 after a day trip from Hilton Head to visit Daufuskie Island teachers Ellen W. Douglas and Frances Littlefield. (Lancy and Emily Burn.)

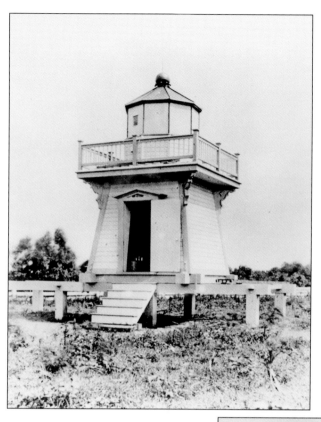

In 1873, the Haig Point Front Range, located 750 yards to the south of the Rear Range light, helped guide ships from the Atlantic Ocean to the Savannah River. The bluff where the Front Range light stood has long since eroded away. Built on five acres purchased by the federal government from the Pope family, the range light roofs were covered with 14,000 cypress shingles produced at the Savannah Shingle Manufactory. After serving in the Union army and confinement in a Confederate prison, Patrick Comer (1820–1891), the first lighthouse keeper, arrived on Daufuskie with his wife and assistant keeper, Bridget Cody Comer (1820–1885), and daughters Mary Ellen (1858–1895) and Margaret (nicknamed "Maggie," 1864–1930). (Daufuskie Island Historical Foundation.)

The Rear Range at Haig Point (named for George Haig I) was built in 1873 with the tabby remains of the plantation house as its foundation. The Haig Point lighthouse keepers and dates of service were Patrick Comer (1873–1891), from Ireland; Richard Stonebridge, (1891–1923) from Norway; and Charles L. Sisson (1923–1924), the son of Bloody Point lighthouse keeper Robert Sisson, from Canada. The Haig Point lights were lit for the first time on October 1, 1873. Decommissioned in 1924, the property was sold to M.V. Haas in 1925 for a hunting preserve. Beautifully restored, the Haig Point lighthouse still stands today. (Daufuskie Island Historical Foundation.)

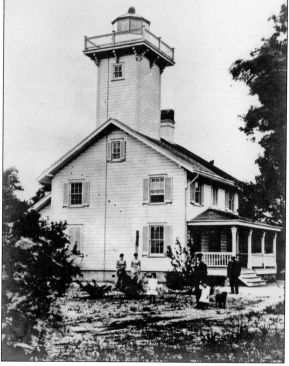

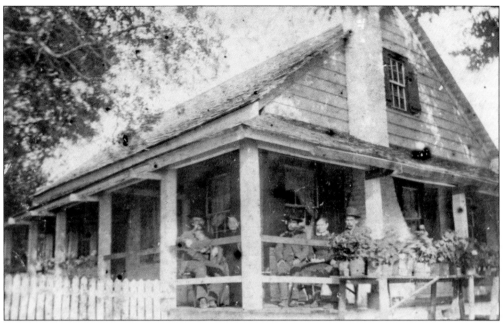

The Fripp house and Palmetto Pavilion landing were located on the New River at the end of what is now Prospect Road. Seen here are, from left to right, Richard Fuller Fripp Sr. (1841–1922); his wife, Margaret Elizabeth Chaplin Fripp (1843–1905), daughter of James Peto Chaplin Sr. (1818–1865) and Mary Catherine Rhodes Chaplin (1824–1891); and three of their four children, John Francis (b. 1869), Mary H. (b. 1879), and Richard Jr. (b. 1872). Fripp was a boat builder, well known for his sailing bateaux. Today, the property is known as Jolly Shores, a large family compound that is available for rent. (Daufuskie Island Historical Foundation.)

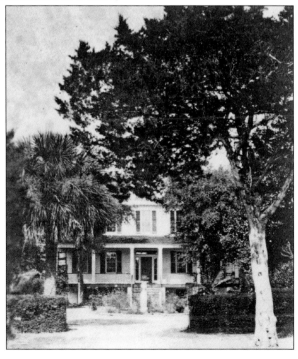

With its expansive gardens and rifle range, Oakley Hall was built as early as 1751 while shipbuilder Robert Watts owned the 400-acre Bloody Point property. Originally from Philadelphia, Watts married Jane Ferguson in 1765 and built the 170-ton *Saint Helena* (1766) and the 260-ton *Cowles* (1772), renamed *Friendship*, commissioned by slave trader and statesman Henry Laurens (1724–1792). The Wattses' daughter Sarah inherited Bloody Point after her father's death in 1775 and married John David Mongin in 1790. When the remains of the house were taken down in the 1930s, oak pegs, used in ship construction, were found, as opposed to nails, increasing the likelihood that Oakley Hall was built by Watts. (Daufuskie Island Historical Foundation.)

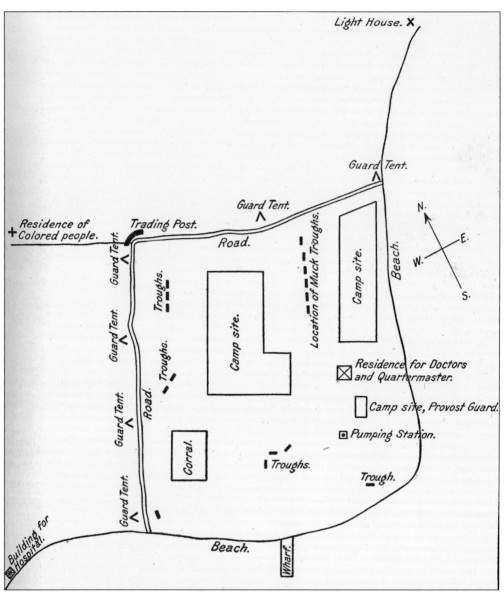

In 1899, at the end of the Spanish-American War, the Stoddard family leased land at Bloody Point to the federal government for a five-week quarantine detention camp to ward against the spread of yellow fever to the mainland. Sapelo Island was considered as a location for the camp but lacked adequate wharves. Oakley Hall became the headquarters and housed doctors, quartermaster Capt. Frank W. Woodring (1870–1945), and all quarantined women. This map was drawn by assistant-surgeon Rudolph Hermann von Ezdorf (1873–1916) of the US Marine-Hospital Service. During the first week of April, as infrastructure was put in place, farmers from surrounding islands landed their boats on the beach, selling eggs and produce to the troops. Von Ezdorf, medical officer in charge, arrived on April 11 to establish the camp boundaries and to oversee hospital services, the water supply, food preparation, sanitary facilities, waste removal, and trading and guard posts. Von Ezdorf banned local supply boats, and anyone who went outside the newly fenced perimeter was threatened with arrest and an additional five-day detention. (Theodore Roosevelt Collection, Harvard College Library.)

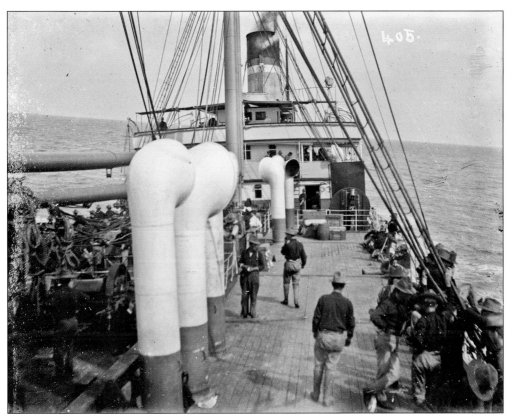

On April 19, 1899, the USAT *Thomas,* named after Gen. George Henry Thomas, brought the Detroit Light Guard's 31st Michigan Volunteer Infantry from Cuba to Cockspur Island, Georgia, for fumigation before a mandatory five-day quarantine on Daufuskie. The troops had been away from home for 12 months, with more than two months spent protecting property in the towns of Cuba's Santa Clara Province. During their return from overseas, passengers were well fed and were able to buy ginger ale, beer, and tobacco on board. Exotic mementos included monkeys, a pet hog, and 300 parrots. Eight men decided to stay in Cuba "as there were good prospects for intelligent and energetic Americans on the island." (Burton Historical Collection, Detroit Public Library.)

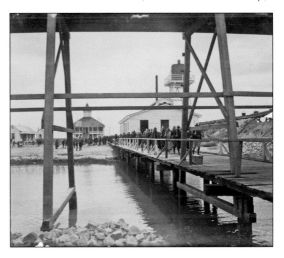

Immediately after disembarking on Cockspur Island, the regiments walked through a steam house for disinfection. Luggage, bedding, equipment, and clothing were treated with formalin (formaldehyde and methanol) and steam (220 degrees Fahrenheit for 30 minutes) and then held for 48 hours. Leather goods were soaked in an alkaline solution, but many boots and belts disintegrated. Kitchen equipment was lost when a small transport boat sank during a delivery from ship to shore, making the first few cold and rainy days miserable for the troops. (Theodore Roosevelt Collection, Harvard College Library.)

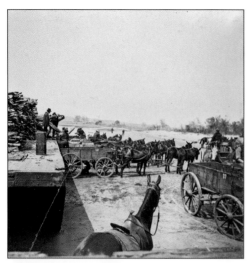

The quarantine detention camp was equipped to shelter 2,000 people. Over the course of five weeks, 431 officers, 9,278 enlisted men, and 846 civilians were ferried from Cockspur to Daufuskie for their five-day stay. "Suspended 30 or 40 feet above the water [horses and mules] were lowered onto lighters that took them to shore. One can only imagine the horse's fright," wrote Capt. James E. Whipple in *The Story of the Forty-Ninth* (1903). Tents were pitched in long rows parallel to the waterfront. Supplies were hauled through the grounds on mule-led wagons. A wharf for landing boats and unloading equipment was built at the southern tip of Bloody Point. (Theodore Roosevelt Collection, Harvard College Library.)

Infrastructure for the camp included waste troughs lined with lime and sand that were flushed out by seawater at high tide twice a day. A 300-foot artesian well, a steam pump, and a 6,000-gallon storage tank that held water for night use were plumbed to distribute water throughout the camp. In 1904, Henry Mongin Stoddard made an unsuccessful attempt at selling the much-improved Bloody Point property: "The place contains about 400 acres of fine land . . . 15 room house, two ever flowing artesian wells, and a fine new steamboat wharf 200 yards from house." (Theodore Roosevelt Collection, Harvard College Library.)

"The island was flat, with a broad, sandy beach all around its edge, making an excellent place for bathing, and the boys enjoyed the situation to the utmost," reported Alma Lake, a sergeant in L Company of the 31st Michigan Volunteer Infantry. He kept a diary and took photographs throughout his regiment's Spanish-American War deployment. Some of his writings and images were published in a book entitled *The Detroit Light Guard* (1900) by Walter E. Clowes. Pvt. William Lingelbach of the 49th Iowa Volunteer Infantry referred to Daufuskie as "Camp Can't Get Away" in a letter to his family and recounted the many wrestling matches organized "to break up the monotony." (Burton Historical Collection, Detroit Public Library.)

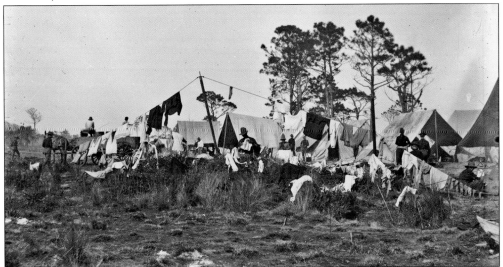

Assistant-surgeon Rudolph Hermann von Ezdorf estimated that 400 people lived on Daufuskie in 1899: "I had established a point for a trading post on the lines to the north-west, where the colored residents of the island could sell their goods, but this was afterwards abolished as the privilege was abused." Supervised by quartermaster Frank Woodring, islanders were hired as laborers on five-day shifts (following the prescribed yellow fever health regulations) to provide laundry service and general maintenance. (Burton Historical Collection, Detroit Public Library.)

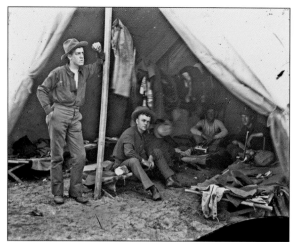

Regiments shipped from Cuba to Daufuskie included the 3rd Kentucky, 2nd Louisiana, 3rd Nebraska, 2nd US Engineers, 6th Ohio, and 2nd Infantry Regiment. The 9th Illinois boarded the *Dixie*. The 31st Michigan Volunteer Infantry and the 3rd US Engineers boarded the *Thomas* at Cienfuegos. The 4th Tennessee, 49th Iowa, and 6th Missouri volunteers left Havana on the *City of Havana*. "Being just from Cuba we were well supplied with good cigars," wrote Capt. James E. Whipple in 1903. (Burton Historical Collection, Detroit Public Library.)

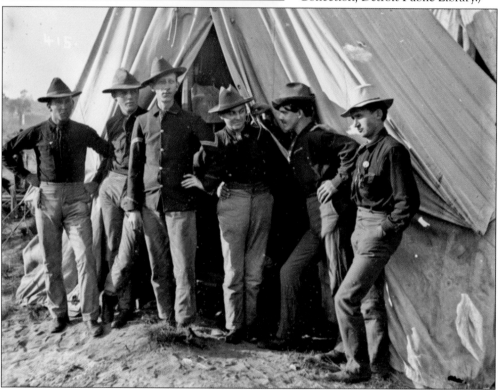

In front of their tent on the beach at Bloody Point are (from left to right) Pvt. William R. Wobbrock, Pvt. Frederick P. Ryff, Cpl. James H. Lindsay, Pvt. Carl G. Scherff, Pvt. Samuel MacIntyer Jr., and Pvt. Peter Gehrke. On April 25, 1899, the 31st Michigan Volunteer Infantry's First and Second Battalions and their band left for Camp Onward in Savannah, now the location of Daffin Park. The program for their final concert included "When Johnnie Comes Marching Home," "Michigan, My Michigan," "Dixie," and "Home, Sweet Home." With Dr. von Ezdorf's certification that "All property of the Army removed, the grounds cleaned, sinks well limed, and troughs and other boxes used for excrement burned," the quarantine detention camp on Daufuskie Island closed on May 8, 1899. No cases of yellow fever were reported. (Burton Historical Collection, Detroit Public Library.)

Two

1900s–1910s

In the 1900 census, Daufuskie's residents were predominantly farmers and fisherman. Working the land and waterways, they fed their families and supplied mainland markets. By the early 1900s, L.P. Maggioni & Company had a well-established oyster cannery employing workers from Daufuskie and neighboring islands, and about 50 Polish workers who lodged seasonally in a 15-room dormitory. Men were employed as pickers, and women and children worked as oyster shuckers.

In 1907, Bloody Point lighthouse keeper Robert A. Sisson (b. 1871) and Richard Stonebridge (b. 1875), a widower, who lived at the Haig Point lighthouse with his children Joseph (b. 1886), Carl (b. 1888), and Sigray (b. 1893), were empowered to enforce laws on behalf of the Game Wardens Commission. In 1912, Beaufort County appointed William W. Scouten as the Daufuskie Island magistrate. Constables and game wardens were appointed, though all positions were later decided by election.

The federal government bought the Webb Tract, named for Samuel Webb (d. 1836), at auction after the Civil War and, in 1875, sold a 300-acre portion to William D. Brown, a Hilton Head merchant. In 1910, Brown awarded a five-year timber lease to Laurence E. Ackerman. The Hilton & Dodge Lumber Company began logging the property using oxen and railcars pulled by a small engine to move timber to the dock on railroad tracks laid across the island.

In 1910, Iona Coston, a graduate of Georgia State Industrial College for Colored Youth, came to teach black students in one of Daufuskie's churches or praise houses when the island population included approximately 600 black and 40 white residents. By 1904, most white children were taught in vacant houses with teachers sent by Beaufort County until the Daufuskie School was built in 1913. Statistics from the Beaufort County School District in 1916 revealed the disparity in annual expenditure per student: $1.89 for black students and $17.86 for white students.

To support the needs of the island's businesses, residents, and visitors, a general store and post office were built in 1912 near the public landing. More than 20 men left Daufuskie to serve in World War I. The first infestation of the Mexican boll weevil in South Carolina was reported in 1917 on Daufuskie Island, and the cotton crop was completely decimated by 1920, taking with it the last vestige of the island's plantation economy.

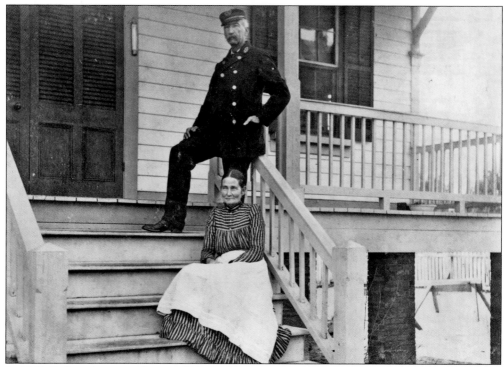

In 1900, Robert Augustus Sisson, the second Bloody Point lighthouse keeper, stands by his wife, Martha (b. 1847), on the steps of the keeper's quarters. The keeper's dress code specified a double-breasted coat, a single-breasted vest, trousers "cut in the prevailing style," and a dark blue cap or canvas helmet with a "yellow-metal light-house badge." One set of casual and dress uniforms were provided, tailored to the keeper's measurements. It was said that the uniform requirement "adds much to the appearance of the personnel, and does much to raise the esprit du corps, and to preserve discipline." (Daufuskie Island Historical Foundation.)

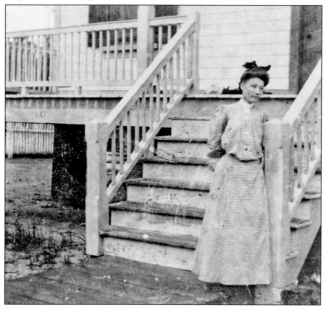

Katie Sisson (b. 1876) is seen here at the Bloody Point keeper's quarters where she lived with her parents, Robert and Martha Sisson. The third of four children, her siblings were Charles (b. 1872), Helen (b. 1874), and Frederick (b. 1879). The Bloody Point lighthouse keepers and their years of service included John Michael Doyle (1883–1890) from Ireland, Robert A. Sisson (1890–1908 and 1910–1912) from Canada, his son Charles Sisson (1908–1910), and Gustaf Ohman (1912–1922) from Sweden. (Daufuskie Island Historical Foundation.)

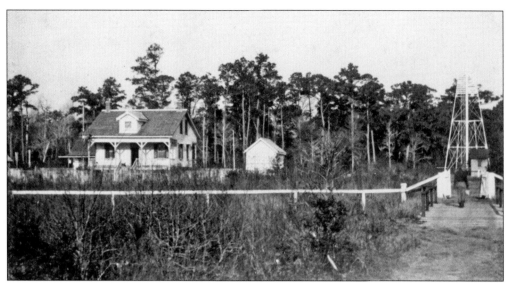

In 1882, the federal government purchased 300 feet of beachfront, a five-acre inland parcel, and a right-of-way from Henry Mongin Stoddard for the Bloody Point lighthouse complex. The construction of the Front Range, with the range light in the dormer window of the keeper's dwelling, was overseen by James C. LaCoste. LaCoste had considerable engineering experience, including working with pilot Robert Smalls of Beaufort to salvage the USS *Keokuk's* sunken eight-ton Dahlgren cannons from Charleston Harbor in 1863. When erosion threatened the Front Range light in 1899, the dwelling was moved inland by the Rear Range tower, seen here in 1900. (Daufuskie Island Historical Foundation.)

In 1883, John Michael Doyle (1847–1901), the chief machinist for Cooper Manufacturing Company of Mount Vernon, Ohio, oversaw construction of the 91-foot Bloody Point Rear Range tower and the adjacent brick oil house. After a three-month stay at Henry Mongin Stoddard's Bloody Point property the tower was complete. Doyle admired its "straight lines tapering beautifully against the sky." When the construction crew was away, his only company was housekeeper and cook Pender Jackson Hamilton, who was born into slavery at Kelvin Grove Plantation on St. Simon's Island, Georgia, and was the great-grandmother of Daufuskie resident Cleveland Bryan. Doyle served as the first Bloody Point lighthouse keeper, then worked as a fireman in Savannah. (Jenny Hersch.)

25

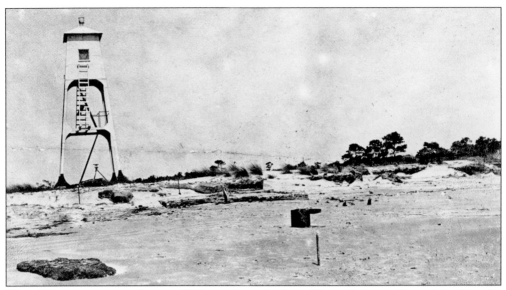

This 45-foot tower, seen here in 1911, was brought from Venus Point on Jones Island in the Savannah River to replace the Bloody Point Front Range light after severe erosion threatened the structure. According to the Lighthouse Board Annual Report of 1900, "The removal was completed in December 1899. There was no interruption of the light of the front beacon. The new site was thoroughly drained and a ditch was dug about 7,000 feet long to connect with a natural outlet." The replacement tower was moved inland several times as erosion continued at the site. (Daufuskie Island Historical Foundation.)

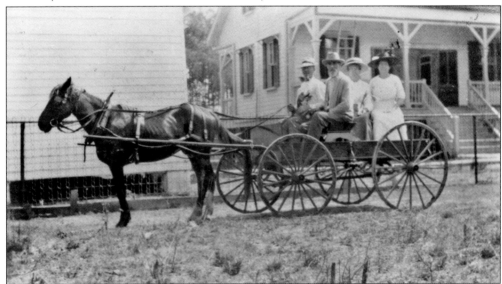

Gustaf "Gus" Ohman (1872–1950) sits on a cart with his wife, Edith C. Loper Ohman (1869–1937), and her parents, James William Loper (b. 1840) and Harriet Griffin Loper (b. 1845), in 1912. Ohman served as the last keeper before the Bloody Point lighthouse was decommissioned on November 15, 1921. His assistants were John A. Robertson Jr. and Arthur Ashley Burn Jr. Ohman purchased the lighthouse in 1924 and sold it to Burn two years later. Today, the Bloody Point lighthouse is home to a museum and gift shop with demonstration plots of cotton, indigo, Carolina Gold rice, and scuppernong grapes. (Daufuskie Island Historical Foundation.)

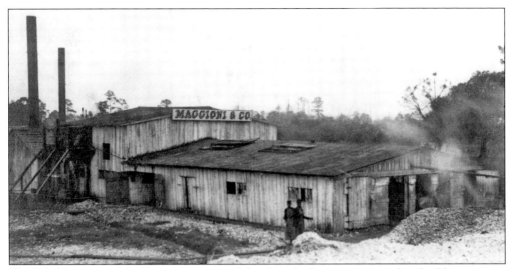

The L.P. Maggioni & Company cannery, with loading dock, steam area, and outbuildings, was in operation on Daufuskie between 1893 and 1903. The land was leased from Minus Sanders (b. 1856), who appears in the 1900 Daufuskie census as a 44-year-old widower and in the 1920 census at age 66, having moved to "Big Bulls Island" with his wife, Affie (b. 1880), and children Benjamin (b. 1900) and Louisa (b. 1903). In 1912, Emanuel "Emil" Cetchovich (b. 1866), an Austrian, bought the land from Sanders and continued to lease it to the Maggioni family. Cetchovich worked as Maggioni's manager, then decided to start his own oyster business on the property. (Lancy and Emily Burn.)

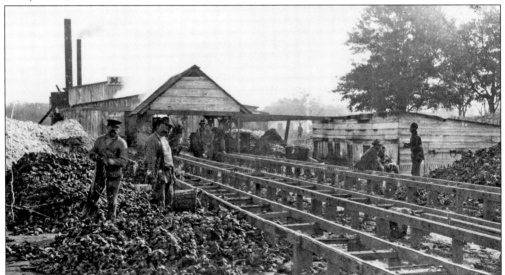

Luigi Paoli Maggioni (1848–1897) and James Peto Chaplin Jr. (1845–1919) opened small raw-oyster shucking operations on Daufuskie in the early 1880s. With the advent of the steam cannery, production increased dramatically. Sailboats and, later, motorboats towed wooden bateaux to the oyster beds. Long-handled tongs, hinged iron grabbers, and rakes were used for harvesting. The work was arduous and often dangerous. Oyster pickers, many of whom could not swim, were at the mercy of the tides. Daufuski Brand oysters, the name (with no "e") used since 1900, was registered in 1920 as a trademark by Gilbert Philip Maggioni (1896–1935) and Joseph Onorato Maggioni (1880–1959). (Lancy and Emily Burn.)

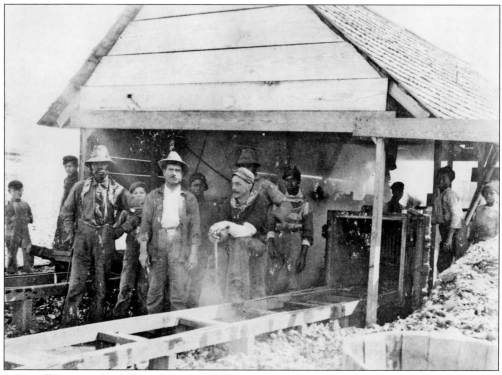

After pulling up at the dock, workers shoveled oysters from their boats into large iron containers that were moved on three sets of iron rails to the steam area. Oysters were steamed for approximately 10 minutes or until their shells opened. Shuckers removed the steamed oysters from the open shells into metal cans hooked on the side of the containers for packing into gallon tins. Men were employed as pickers or harvesters; women and children were shuckers who were paid by the weight or volume of the oyster meat, averaging 40 pounds per day. (Daufuskie Island Historical Foundation.)

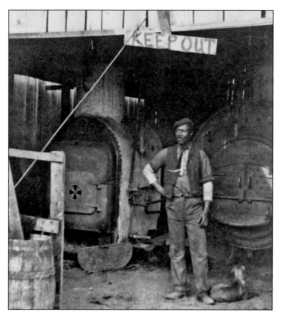

A worker known only as "Jim" manned the boiler at the L.P. Maggioni & Company cannery. Oysters were harvested, steamed, shucked, and canned, then sent on ice to Bluffton and Savannah for distribution. The Graham Ice House was built on Daufuskie around 1910 but no longer exists today. With few options for employment, many Daufuskie residents worked for little pay in the burgeoning oyster industry, including members of the Bentley, Brisbane, Brown, Bryan, Fripp, Grant, Graves, Hamilton, Heyward, Holmes, Hudson, Jenkins, Jones, Lawrence, Locke, McGraw, Miller, Mitchell, Myers, Robinson, Simmons, Smith, Stafford, Washington, White, Wheelihan, Wiley, Williams, and Wilson families. (Daufuskie Island Historical Foundation.)

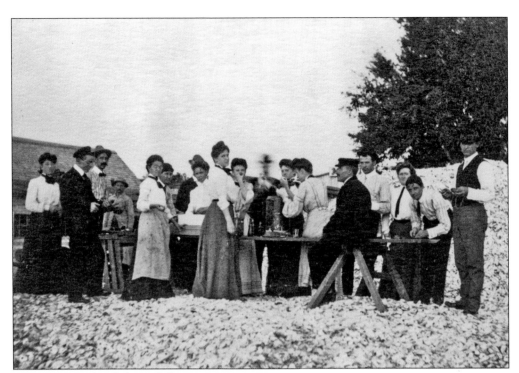

The Maggioni family hosted this oyster roast near the public landing at Benjie's Point. After the Maggioni and Cetchovich oyster operations closed down, John Samuel "Junior" Graves (1910–1964), having taken over his father's substantial oyster business in Bluffton in the 1930s, expanded to Daufuskie Island in the 1940s. Ads for "Daufuski Oysters" could be found in newspapers throughout the country starting in 1930, when a five-ounce can sold for 15¢. In the 1970s, L.P. Maggioni & Company contracted with a company in South Korea for a new source of oysters and packaging, then sold the brand to Liberty Gold Fruit Company in California. (Daufuskie Island Historical Foundation.)

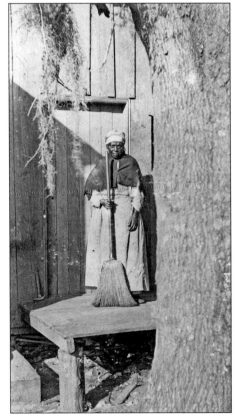

Little is known about "Aunt Elsie," but she is thought to have worked for L.P. Maggioni & Company as a housekeeper and cook, likely at the "Hickey House," a dormitory built for Polish workers who lived on Daufuskie during the oyster season. Oysters are not harvested in the summer months when they spawn, but the cannery continued operations, processing local fruit, vegetables, and shrimp, giving oyster shuckers an opportunity for year-round employment. (Daufuskie Island Historical Foundation.)

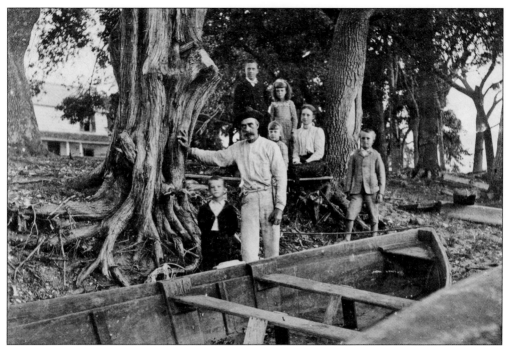

Boat builder and oysterman James Peto Chaplin Jr. (1845–1919), son of James Peto Chaplin and Mary Catherine Rhodes Chaplin, is seen here in front of his house at Benjie's Point by the public landing. He is joined by his wife, Tallulah "Lou" Clifford Millen Chaplin (1857–1939), and children (from left to right) William Francis (b. 1895), Georgia Clifford (b. 1893), James Peto III (b. 1886), Mary Harriet (b. 1891), Virginia Susan (b. 1884), and Robert Lee (1888–1979). In 1921, the Chaplins sold their house, built in the 1890s, to members of the Union Brothers & Sisters Oyster Society to be used as their meeting hall. (Jenny Hersch.)

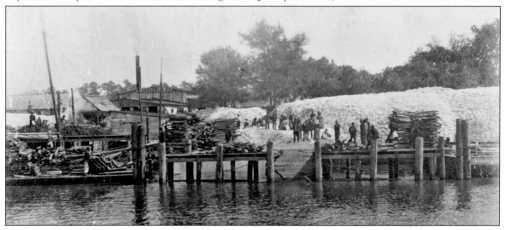

With timber deeds secured, the arrival of the Hilton & Dodge Lumber Company of Darien, Georgia, in the early 1910s transformed the island landscape. Iron railroad tracks were laid, running from the southern end of the island at Jimmy Lee's landing near Bloody Point up to Freeport Plantation. Three branches split from the main track for a narrow-gauge train with flatbed cars that carried timber to the waterfront. Rough-cut logs were rafted together and towed to steam-operated sawmills. Once milled, pine and cypress boards were transported from Georgia to New England and as far away as Russia, Scandinavia, and Brazil. (Lancy and Emily Burn.)

Evelyn Byrd Pollard Stoddard (1877–1973) sits with her son Dan Hamilton Stoddard (1912–2003) on the porch at Melrose in 1912. She married Albert Henry Stoddard Jr. (1872–1954) in 1909 and had two more sons, Spotswood Douglas Stoddard (1913–1964), and Albert Henry Stoddard III (1920–2005). The father of Albert Henry Stoddard Sr. (1838–1918), John Stoddard II, married Mary Lavinia Mongin in Paris in 1836. It was through her inheritance, after the deaths of both her mother and grandfather in 1833, that the Stoddards came to Daufuskie in 1837. (Daufuskie Island Historical Foundation.)

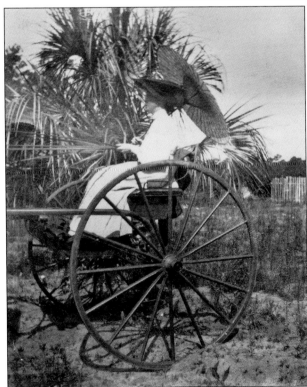

With a parasol to protect her from the sun, Evelyn Stoddard rides in her two-wheeled, horse-drawn carriage. She became the island's second postmaster in 1911 after James Peto Chaplin Jr., who was appointed by the postmaster general in Washington and served from 1892 to 1908. Stoddard established a post office in the Melrose barn and oversaw the distribution of mail that was delivered from Savannah to the public landing several times per week. In 1912, the Melrose mansion was destroyed by fire. The Stoddards then built a smaller home nicknamed the "Boathouse." After leaving Daufuskie permanently in 1918, Evelyn Stoddard opened an antiques store on Bay Street in Savannah called Stoddard & Roche. (Daufuskie Island Historical Foundation.)

After graduating from Williams College in 1859, Albert Henry Stoddard Sr. traveled to Europe and Egypt, served in the Confederate army, and was held prisoner for three months at Fort Delaware before settling on Daufuskie. From his travels, he brought back an array of decorative pieces for his home at Melrose. Lighthouse builder John M. Doyle noted the mansion's stunning interior in his 1883 diary. "The place is a beautiful one inside and out," he wrote. "The house is filled with rich and rare objects from all parts of the globe." (Daufuskie Island Historical Foundation.)

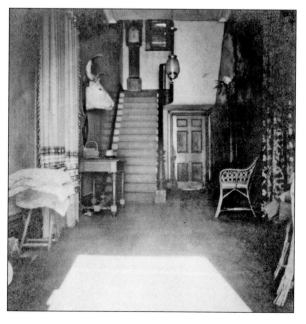

This bull's head was the first thing John M. Doyle noticed during his initial visit to the Stoddards' Melrose home. He discovered that the horns were not original to the bull, but had been purchased in Rome by Albert H. Stoddard Sr. Over the years, the Stoddard family hosted many parties and entertained visitors, including Lydia Parrish, wife of artist Maxfield Parrish, who acknowledged their generosity in her book *Slave Songs of the Georgia Sea Islands* (1942). Albert H. Stoddard Jr., a writer himself, transcribed several sea island folktales in small yarn-bound books printed at Ashantilly Press in Darien, Georgia. In 1949, he recorded many stories for the Library of Congress. (Daufuskie Island Historical Foundation.)

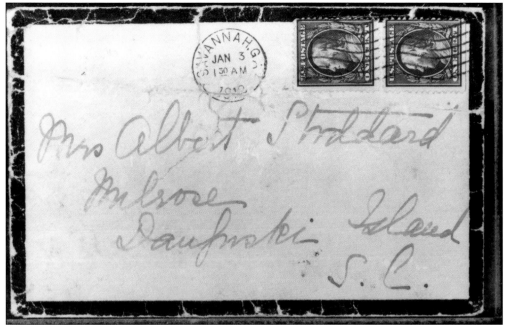

The black border on the front and the "X" across the back of this envelope served to alert the recipient that someone they knew had died. Known as "mourning stationery," the letter itself, also black-bordered, was sent from Savannah to Evelyn Stoddard. A carryover from the Victorian era, envelopes marked in this way could be sent for a set price regardless of the distance. Dated January 3, 1912, this piece of mail is said to have the first Daufuskie Island postmark. (Both, Daufuskie Island Historical Foundation.)

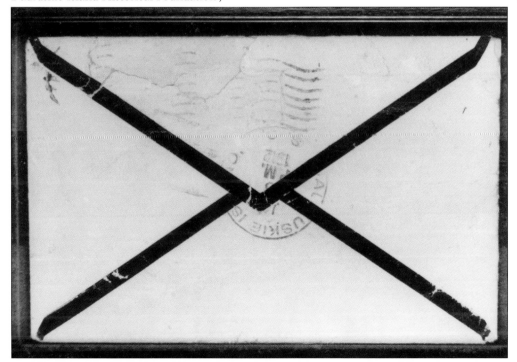

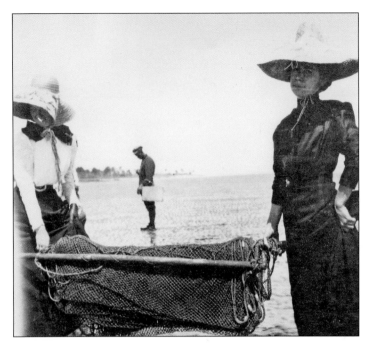

Evelyn Stoddard (right) and a friend hold a seine net on the beach by the Melrose mansion in 1912. As was customary at the time, for modesty's sake, the women are wearing broad-brimmed sun bonnets and full-length bathing gowns covering them from head to toe. The heavy fabric is weighted down at the bottom, much like a cast net, to keep their skirts from riding up in the water. The thickness of the material prevents it from being see-through when wet. (Daufuskie Island Historical Foundation.)

Dressed in lighter ware, Evelyn Stoddard (right) and her companion look on just after a shark was caught at the Melrose pier. Leisure time was spent walking on the beach, admiring the roses and other plantings while strolling down the gravel paths of the multi-acre garden, reading in the extensive library, or playing the instruments in the mansion's music room. The Stoddard family was known for their hospitality, often entertaining guests at their Daufuskie home. (Daufuskie Island Historical Foundation.)

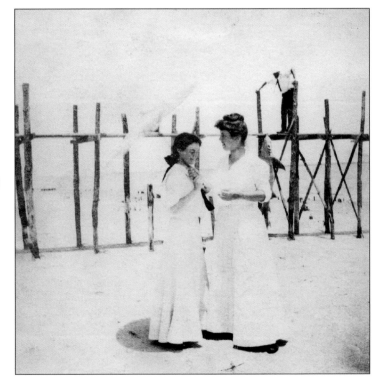

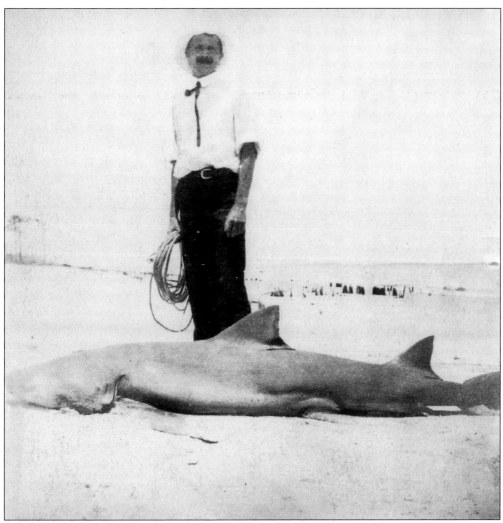

This eight-foot-long shark took the strength of three men to hoist onto the Melrose pier, then onto the beach. Sharks were (and still are) abundant off Daufuskie's shores. The waters can be treacherous with stingrays, jellyfish, razor-sharp oysters, quicksand-like pluff mud, rip currents, and extreme tides. In 1901, six people, part of a group of 175 who made an annual beach trip to Daufuskie from Savannah, drowned as they tried to make their way back to shore before the rising tide. (Daufuskie Island Historical Foundation.)

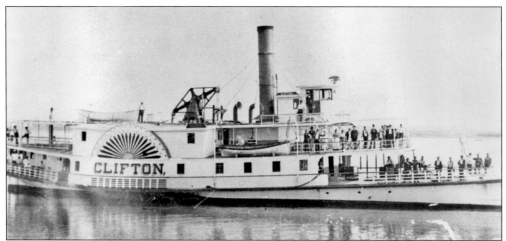

The *Clifton*, seen here in 1912, was one of many steamers that ran between Savannah, Beaufort, Bluffton, and Daufuskie. On August 17, 1897, the *Clifton* offered a two-hour "grand moonlight excursion" from Savannah to Daufuskie for 50¢ per person. The Friday before, steamers *John Rourke* and *Bessie M. Lewis* brought members of Savannah's First Bryan Baptist Church and Second African Baptist Church for the Zion Baptist Association weekend Sunday School Convention at the "Daufuskie Baptist church, Reverend B. H. Renair, pastor." The *Clifton* sank in the Beaufort River in the early 1910s. (Daufuskie Island Historical Foundation.)

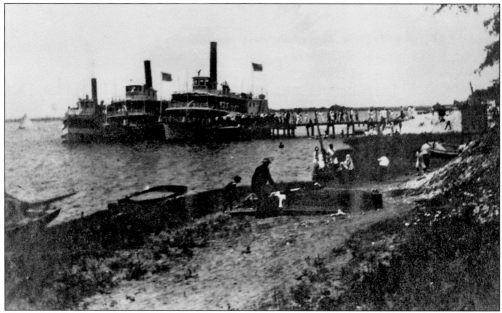

With steamers *Attaquin*, *Clivedon*, and *Pilot Boy* docked three deep, the public landing at Benjie's Point on the New River was a bustling spot on Daufuskie. Island industries made use of the dock, moving workers and their cargo on and off. In the summer months from 1897 until 1910, church groups, social groups, and pleasure seekers from Savannah made daily excursions to the island. Such groups included the Twilight Reaper's Aid and Social Club, the Hebrew Gamahl Hasad, the Union Brotherhood Benevolent Association and Ladies Branch, the Ladies and Gentlemen's Soiree Club, the First Bryan Baptist Sunday School, the Hyacinth Aid and Social Club, and the Teddy Bears. (Lancy and Emily Burn.)

Three

1920s–1940s

In 1921, the Union Brothers & Sisters Oyster Society purchased the Chaplin house for use as their meeting hall, which they likely shared with island chapters of the all-black Knights of Pythias and the Odd Fellows. The Willing Workers, another benevolent society, was organized on Daufuskie as well. In 1922, Daufuskie teacher and Pennsylvania missionary John O. Daniels of Jamaica, who in 1920 began teaching school in the Oyster Society Hall, traveled north and "delivered an interesting address" at the African Methodist Episcopal Zion Church in Auburn, New York. In the early 1920s, folklorist Elise Clews Parsons visited with Daufuskie residents Henry and Henrietta Lee, Henry Bryan, and Jack Brown as she collected material for her book *Folk-Lore of the Sea Islands, South Carolina* (1923). This comprehensive account, still in print today, piqued interest in sea island culture. Oyster-shucking houses and work on dredge boats provided much of Daufuskie's employment. The federal government's Works Progress Administration (WPA) created jobs on and off the island.

Frances Jones began her legendary teaching career as a teenager at the Maryfield Praise House and at the First Union African Baptist Church as a 20-year-old in 1930. The Mary Field School, the island's first public school for black children, was built in 1934; Miss Frances taught there for 35 years. Completed by 1939, the Jane Hamilton School was built to serve black children on the northern end of the island. Built in 1901, the original Mount Carmel Baptist Church and praise house, home of the Cooper River School, were destroyed by a hurricane in 1940. Construction of Mount Carmel Baptist Church No. 2 was completed in 1941.

Plans for a bridge to Daufuskie were developed in 1935, and an airport was proposed in 1946, though neither were funded. More than 20 men from Daufuskie, both black and white, served in World War II. The US Coast Guard was stationed on the island from 1942 to 1944. The shoreline was patrolled on horseback, and telephone lines were strung in the trees along the beach to communicate with the mainland. In the winter of 1943, as reported by Leon Delvers Bond Jr., a German submarine was spotted off Daufuskie's shore. Planes from Hunter Field in Savannah were called, and four bombs were dropped. Later, on the incoming tide, several life jackets, oil slicks, bread, and pieces of clothing were discovered, though the sinking was never confirmed.

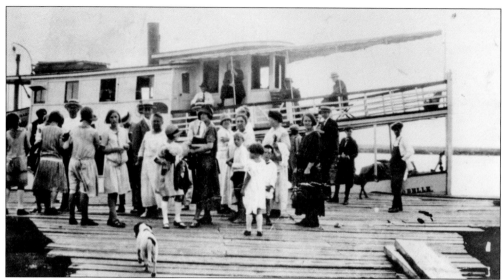

Members of the Fripp, Goodwin, Palmer, Ward, White, and Williams families board the *Isabelle* at the public landing on the New River in 1924. From the late 1800s to the early 1900s, more than a dozen commercially operated boats ferried passengers and freight between Daufuskie Island, Beaufort, Bluffton, and Savannah. Piloted by Capt. George Conner, the *Isabelle* was destroyed by fire in 1929. (Daufuskie Island Historical Foundation.)

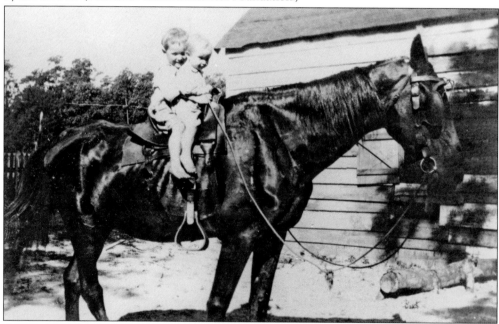

Francis Arthur Burn (1916–2005) and his sister Leonella Lillian Margaret Burn Greiner Padgett (1918–2009) take a ride on their horse Maude by the barn near the Bloody Point lighthouse in 1919. Their father, Arthur "Papy" Ashley Burn Jr. (1878–1968), came to Daufuskie in 1913 with his first wife, Catherine Elizabeth Nolte Burn, and five children: Bessie, Louise, Ashley, Theodora, and Lance. Frank and Nell are his children with his second wife, Margaret Catherine Keenan. Her father, Francis Keenan, bought the Bloody Point lighthouse property at auction in 1922. (Daufuskie Island Historical Foundation.)

In 1914, at age seven, William Wiser Scouten Jr. (1907–1965) rode to school with a group of children in a horse-drawn wagon driven by his mother and schoolteacher, Myra Gage Scouten. Once, after jumping out of the wagon and running alongside, he tried to climb back in but his foot slid into the spokes. With his left leg severely broken, he was taken to the hospital in Savannah on the steamer *Pilot Boy*. His leg was amputated but his life was saved. The boy on the right could not be identified. (Daufuskie Island Historical Foundation.)

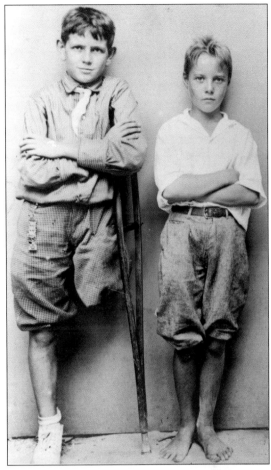

William Wiser Scouten Sr. (1873–1940) bought the 1,100-acre Haig Point Plantation from the family of William "Squire" Pope in 1899. Scouten married Myra Dana Gage (1871–1955) in 1902 and built this house (torn down in the 1960s) near the Haig Point lighthouse facing the Cooper River. They had two children, George Gage Scouten (1903–1973) and William Wiser Scouten Jr. Scouten Sr., having served as a lieutenant (junior grade) in the US Naval Reserve Force, worked as a farmer and served as the magistrate for Daufuskie Island in 1912, a position funded by Beaufort County. (Lancy and Emily Burn.)

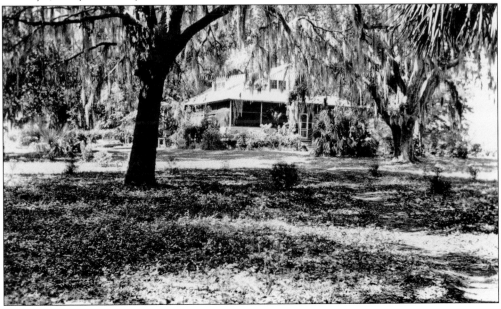

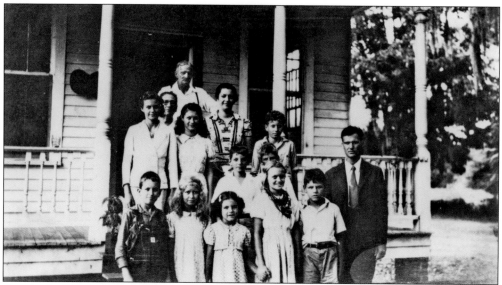

Seen here in the 1930s are Daufuskie School students from the Burn, Goodwin, Keenan, Palmer, and Ward families. In 1913, Richard Fuller Fripp sold a fourth of an acre of land to the Beaufort County School District for the school, built by carpenters from Bluffton. The first school teacher, Myra Gage Scouten, taught until 1918, then returned from 1926 through 1934. The school opened and closed several times between 1945 and 1959 due to lack of enrollment and closed permanently in 1962. Today, the building, still owned by Beaufort County, houses the archives of the Daufuskie Island Historical Foundation. (Daufuskie Island Historical Foundation.)

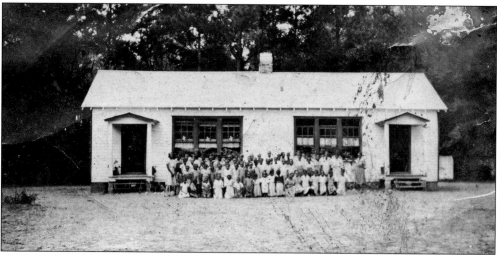

The Mary Field School, built on land purchased from the estate of John Martin (b. 1861), opened in 1934 with 108 students taught by Frances Jones and Gertrude Bryan. A Charleston newspaper praised islanders for contributing half the funds necessary for construction: "The Daufuskie Educational Institute . . . has donated . . . $300, to supplement the money given by the Civil Works Administration to build a school house. . . . Some of this money was in twenty-dollar gold certificates." Built by Samuel Holmes, Dennis Young, Gabriel Washington, Joseph Riley, Robert Jenkins, Hinson White, Albert Gage, Charles Myers, Henry Hamilton, and employees of the Works Progress Administration, the school closed in 1995 and is owned by the First Union African Baptist Church. (Paul Johnson.)

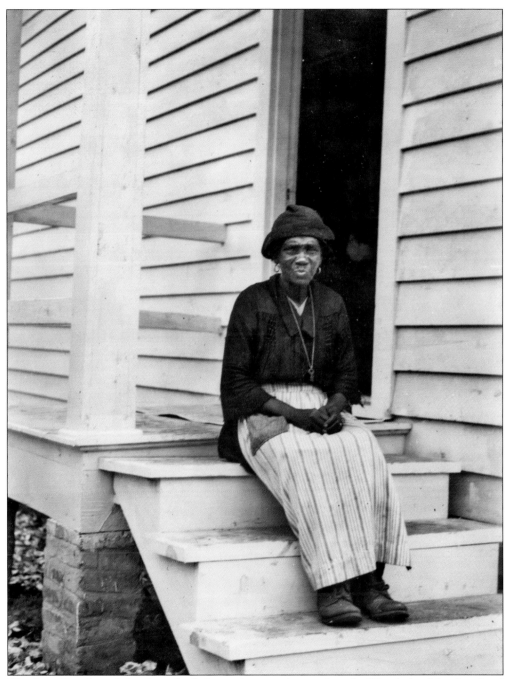

The Jane Hamilton School was built for students at the north end of Daufuskie Island on land donated by Jane Hamilton (1867–1961) in 1938. She is seen here on the steps of the school in 1939. Miss Janie was commended for her contribution by J.B. Fulton, South Carolina state agent for Negro schools. When the school closed in 1950, she made the building her home until her death in 1961 at age 94. Today, the Jane Hamilton School is part of the Daufuskie Island Historical Foundation's museum complex and houses the island's community library. (Rockefeller Archive Center.)

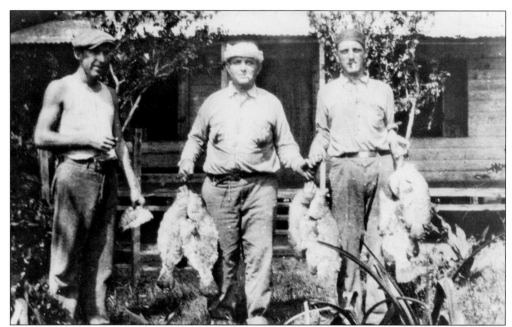

Located at the southwest corner of Bloody Point, this 10-acre parcel on Mungen Creek was sold to John M. Doyle by Henry Mongin Stoddard in 1891. After subsequent sales, Arthur "Papy" Burn Jr. purchased the property in 1927 and called it the "Little Place." The site was one of at least 10 oyster-shucking shacks along Daufuskie's shoreline. The landing provided easy access to the water to fish, shrimp, crab, and harvest oysters. (Daufuskie Island Historical Foundation.)

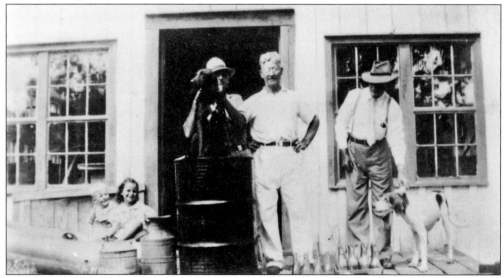

Gustaf Ohman built this store and post office near the public landing at Benjie's Point in 1912. Seen here from left to right are Kenneth "Kenny Mack" Johnson (b. 1938), Sarah "Georgia" Johnson (1935–2016), unidentified, Gustaf Ohman, and James Goodwin (b. 1876). Ohman ran the store and post office with his wife, Edith. After her death in 1937, he leased the store to Malcolm Julius Johnson (1909–1979) and Josephine Walker Johnson (1916–2003) in 1938. On December 25, 1932, Gus Ohman took Pres. Herbert Hoover fishing. Having no luck, they had an oyster roast for Christmas dinner on Ossabaw Island, Georgia. (Daufuskie Island Historical Foundation.)

Hinson Adams White (1899–1985), who was one of 11 children, moved to Daufuskie Island in 1902 with his family, as sharecroppers on the Stoddard property. At age 25, he married Agnes Palmer (b. 1908) and had two daughters, Anne (1926–2015) and Ida (1930–2009). In 1933, White traveled to Pritchardville, near Bluffton, to meet with farm agents to discuss the agricultural future of the sea islands. Seen here riding Daisy in 1939, White was a farmer, an oyster worker, did road maintenance, and worked on dredge boats that cleared channels through the local waterways. (Daufuskie Island Historical Foundation.)

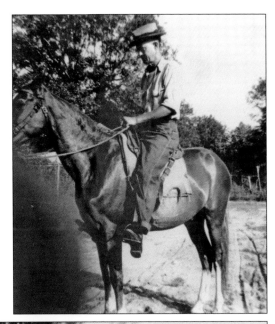

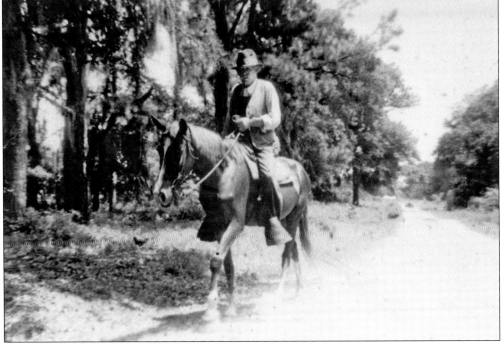

James William White (1863–1948), father of Hinson White, seen here in 1940 riding Billy, had 11 children with his wife, Annie E. White (1870–1948). The children had to miss class at the Daufuskie School when they were needed to pick cotton, a regular occurrence according to Hinson White. In 1918, a year after the boll weevil began wreaking havoc on the island's cotton plants, the Stoddards leased their Melrose acreage to the Seacoast Farm Company, owned by Murray McGregor Stewart, who later became mayor of Savannah. In 1919, as the boll weevil continued to destroy the cotton crop, the White family was employed directly by Seacoast to supply produce to the company. (Daufuskie Island Historical Foundation.)

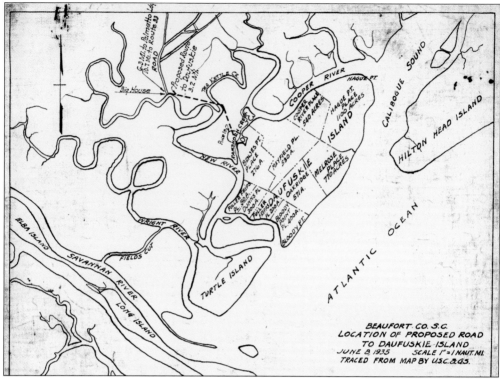

BEAUFORT. CO. S.C.
LOCATION OF PROPOSED ROAD
TO DAUFUSKIE ISLAND
JUNE 8, 1935 SCALE 1"=1 NAUT.MI.
TRACED FROM MAP BY U.S.C.&G.S.

In April 1935, South Carolina state senator W. Brantley Harvey and state representative Calhoun Thomas proposed a General Assembly study to create a "road" that would connect Bluffton to Daufuskie Island. The Daufuskie Bridge Commission favored a plan that included four causeways and two fixed bridges from Palmetto Bluff to Daufuskie at "Mungin Corner" where Governors Point is today. Deferred as "after war work," the project was never built. (Georgia Historical Society.)

120 MILES OF SEA BREEZE

STEAMER CLIVEDON
Savannah to Beaufort, S. C. and Return

Leaves Savannah, foot of Abercorn St.
Tuesdays and Fridays 8:30 A.M.
Sundays 9:00 A.M.
Returning about 9 o'clock P. M.

ROUND TRIP $1.00
Parties of 10 or more, 80c each Children, 5 to 12 years old, 50c each

Meals, Drinks, Etc., aboard, or Bring Lunch

BEAUFORT-SAVANNAH LINE, Inc. Phone 3-2814

1936.

In 1936, Samuel H. Tarver and Capt. Thomas Martin purchased the Beaufort-Savannah Line from Charles E. Bell and C.J. Butler. The sale included the steamer *Clivedon* and a wharf, pavilion, and picnic grounds on Daufuskie. The boat ran three times per week for passengers and freight and was available for charters. In the 1930s, the *Clivedon* was the only vessel that stopped at Daufuskie and was destroyed by fire in the 1940s. (Daufuskie Island Historical Foundation.)

The tabby slave cabins at Haig Point, seen here in 1932, were built from the 1820s through the 1850s with a combination of crushed oyster shell, lime from burnt oyster shell, sand, and water. The original pitched-roof structures were 16 feet wide and 24 feet long with seven-foot walls that were eight inches thick. Each had two doors, window openings, and at the east end, a chimney and hearth. There were at least 50 individual slave dwellings on Daufuskie that from the 1770s through 1861, housed approximately 200 enslaved Africans and their descendants at one time. The remains of these dwellings can be seen today. (Daufuskie Island Historical Foundation.)

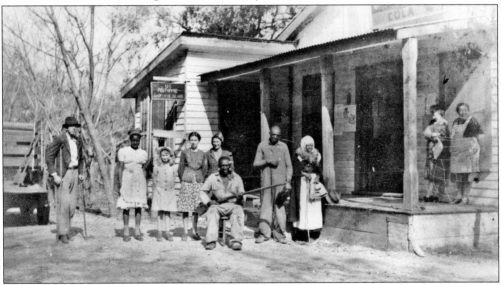

Standing in front of the general store in the early 1940s are, from left to right, Mr. Davis (a pulpwood-logging worker), Daisy Miller, Ida White (daughter of Hinson White), Josephine Johnson (postmaster and wife of store manager Malcolm Johnson), Annie White (daughter of Hinson White), Fred Fraizer, and Annie Crosby. William "Gee Chee" Brown (b. 1885) is seated, holding a Civil War rifle and wearing a horn held by a string on his forehead. Standing on the porch are Marie Perry, a teacher at the Daufuskie School, and Annette Goodwin (b. 1878), who lived at Bloody Point with her husband, James, a Works Progress Administration foreman. (Daufuskie Island Historical Foundation.)

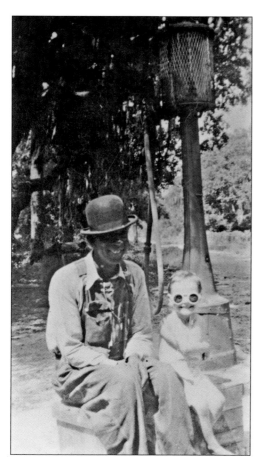

A fisherman by trade, William "Gee Chee" Brown sits with Sarah "Georgia" Johnson. He is listed in the 1940 census at age 55 with wife Daisy, 45, and son George, 12. In 1918, Brown farmed the Webb Tract, leased by the Seacoast Farm Company from William D. Brown (no relation). He often entertained passersby with a doll made of cloth and chicken bones that danced at the end of a stick. In addition to the horn on his forehead, Brown wore a large ring in his nose and smoked Bull Durham tobacco. Gerald Yarborough (b. 1942) has fond childhood memories of fishing with Brown at the public landing. (Daufuskie Island Historical Foundation.)

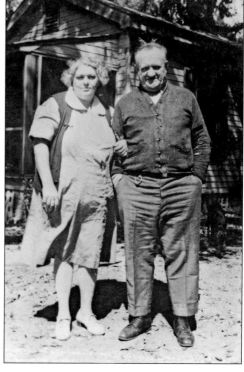

Fred Dierks came to the United States from Hanover, Germany, in 1914. In 1942, he moved to Daufuskie Island from Savannah with his wife, Mary Catherine Myers Dierks. They purchased the Cetchovich property (previously the Sanders property) at Benjie's Point. The Dierkses ran the post office from 1945 through 1963. Fred Dierks maintained roads, drove the Mary Field students to school, chopped wood for the school stove, and picked up the mail in Bluffton along with thousands of pounds of groceries to stock their general-store shelves. Fred and Mary also gave tours and had the only ship-to-shore radio on the island. (Daufuskie Island Historical Foundation.)

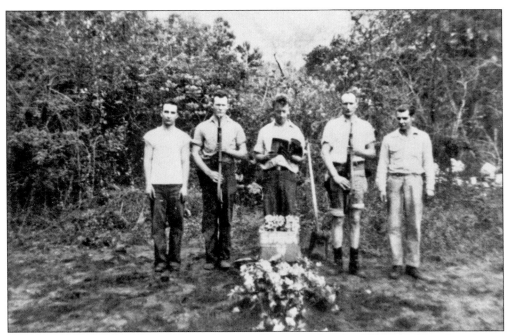

Leon Delvers Bond Jr. (left) of Harris County, Texas, lived at the US Coast Guard station at Melrose from June 1943 until July 1944 after completing basic training on Hilton Head. His duties included riding along the beach on horseback looking for German submarines. While on the island, he met Beatrice Ellis, granddaughter of Arthur "Papy" Burn Jr.; they were married in 1946. Bond is joined by, from left to right, Lester Hobbs, Lawrence Lane, Zeno Graham, and Robert Owens at the burial of their horse Sparky. (Daufuskie Island Historical Foundation.)

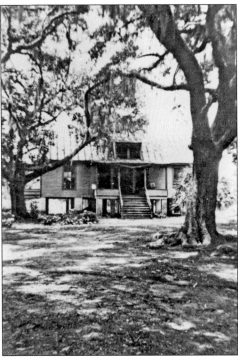

Built with surplus materials, the "Boathouse," was home to the Stoddards after the Melrose mansion was destroyed by fire in 1912. Set back from the beach, the house was built on piers with plenty of storage underneath for boats. In 1918, as the boll weevil continued to decimate their cotton crops, the Stoddards moved permanently from Daufuskie to Savannah. Their house was then rented, and the land was farmed in turn by the Hoskiss, Palmer, White, Goodwin, and Brabham families. The US Coast Guard was stationed here from 1942 to 1944. Torn down in 1969, it was the last building on Daufuskie Island owned by the Stoddard family. (Lancy and Emily Burn.)

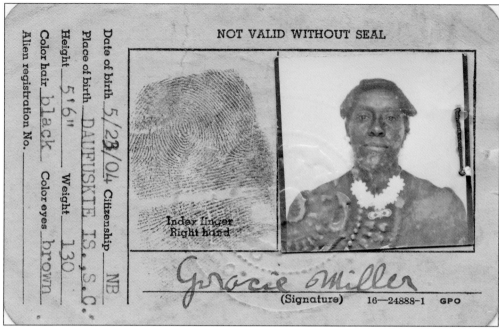

Gracie Haines Miller (1901–1999) was an oyster worker and was employed by the US Coast Guard at Melrose washing and ironing clothes. Miss Gracie worked as a housekeeper and cook for the Cetchovich family in the 1940s and for Geraldine Wheelihan in the 1950s. She was one of seven children born to Joseph (b. 1866) and Josephine (b. 1870) Haines. In 1921, she married Abraham Miller Sr. (1885–1941), who worked on tug and dredge boats. They had four children: Marshall (b. 1923, who attended Savannah State College), Matilda (b. 1927), Laura (b. 1930), and Abraham Jr. (b. 1938). Miss Gracie was on the committee for building the Mary Field School. (Both, Daufuskie Island Historical Foundation.)

N. C. G. 2514 **UNITED STATES COAST GUARD**

IDENTIFICATION CARD

CAPTAIN OF THE PORT SAVANNAH, GEORGIA

NAME GRACIE MILLER

OCCUPATION HOUSEKEEPER

EMPLOYED OR SPONSORED BY MRS EMIL CETCHOVICH JR.
(ORGANIZATION)

ISSUED 5/25/42 EXPIRES indefin SERIAL 06403607

_____ U.S.C.G.

16—24888-1

Four

1950s–1960s

In 1951, electricity was brought to the island across more than 100 utility poles driven into the marshland from Bluffton (at Palmetto Bluff) to Daufuskie at Governors Point. In 1955, during an island-wide tuberculosis scare, the Beaufort Naval Hospital at Parris Island sent a portable x-ray machine to the public landing, where 106 chest x-rays were taken in one day. In 1963, under the direction of Dr. Donald Gatch, diphtheria serum was flown to Daufuskie by Marine helicopter, though too late to prevent the death of a nine-year-old boy.

In 1956, owners of six large tracts entered into a purchase-and-sale agreement with the American Cyanamid Company, which planned to mine the majority of Daufuskie Island. Many test pits were dug (likely searching for titanium) before the company backed out of the deal. That same year, a dwindling labor force and the discovery of pink yeast in some of Daufuskie's oysters (a condition potentially resolved by washing work surfaces with a formaldehyde solution) contributed to the closing of the island's last commercial oyster facility in 1959. Daufuskie's population continued to drop (370 in 1950 to 120 in 1966), with residents seeking new opportunities for education and employment on the mainland. Hearty and self-reliant, more than 100 residents stayed on the island during Hurricane Ginny in 1963 and Hurricane Dora in 1964. Beaufort County sheriff L.W. Wallace was quoted saying, "You can go out there and tell them to leave and they'll look at you like you're out of your mind or something."

The Jane Hamilton School closed in 1950 for lack of enrollment; the disparity in school spending continued with $72 allocated per black student and $188 allocated per white student. The Daufuskie School closed in 1962 following the graduation of what turned out to be the last white school-aged child on the island for the next 20 years. The first VISTA (Volunteers in Service to America) workers arrived in 1965, and in 1968 the first pair of "California Boys" arrived from the University of California Santa Cruz to assist residents wherever help was needed. After 39 years of teaching, Frances Jones was replaced by Pat Conroy at the Mary Field School in 1969. According to a newspaper article, "She retired after county school officials had to integrate the Mary Field School which had all black students and two black teachers."

Befitting the end of an era, Sarah Hudson Grant, Daufuskie's last midwife, delivered her last island-born baby in 1969.

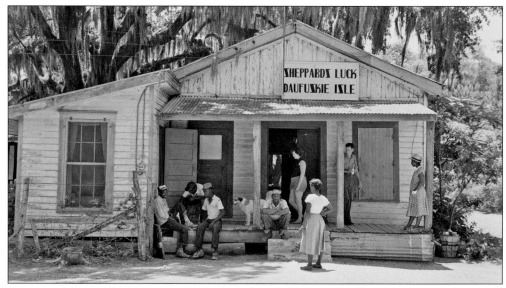

This store built by Gustaf Ohman in 1912 was called Sheppard's Luck when it was owned by George Clary Sheppard in 1952. It was a gathering place where news was exchanged and stories told; dice and card games were played on the porch well into the night. Run by Geraldine Wheelihan (1922–2004) from 1945 to 1960, the store was stocked with supplies from Savannah. These photographs were taken by 18-year-old Constantine Manos in 1952 when he visited Daufuskie from Columbia, South Carolina. He became a noted photographer and, in 1963, joined the prestigious Magnum Photos cooperative. (Constantine Manos.)

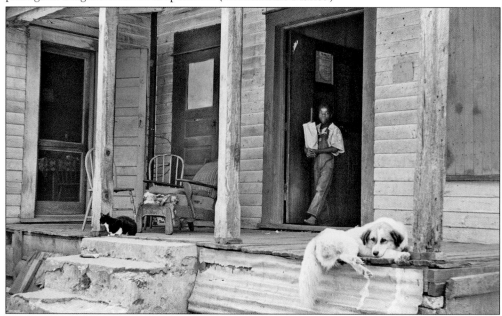

Seen here at age six, Thomas Stafford Jr., son of Thomas Stafford Sr. (d. 1988) and Hattie Hamilton Stafford (b. 1932), leaves the Sheppard's Luck store with a paper grocery bag for a long walk home. Stafford Jr. attended the Mary Field School with teacher Frances Jones and had four siblings: Lillian, Silvia, Odas, and Lasceny. Stafford Jr. moved to Savannah as a teenager and worked as a shrimper for most of his life. (Constantine Manos.)

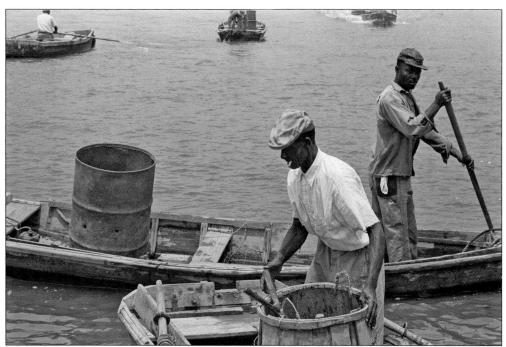

The waterways around Daufuskie provided livelihoods and sustenance for island residents. In handmade wooden bateaux, crabbers plied the creeks and tidal rivers trolling for blue crabs. Three-hundred-foot lines were baited with chicken necks or ham skin on hooks tied every one to two feet. Reeled in carefully, the lines often held several hundred pounds of crabs that were transferred to large metal barrels on the boat deck. The "Crab Man" from Beaufort weighed each barrel of crabs with a crane on his boat, purchasing them for up to 5¢ per pound. (Both, Constantine Manos.)

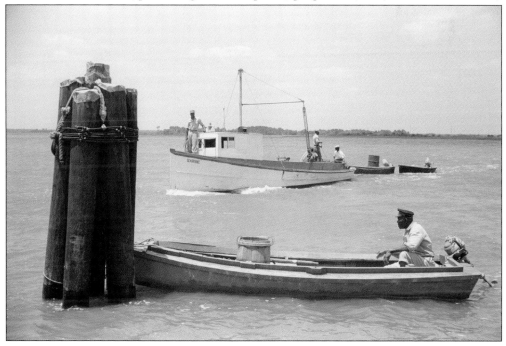

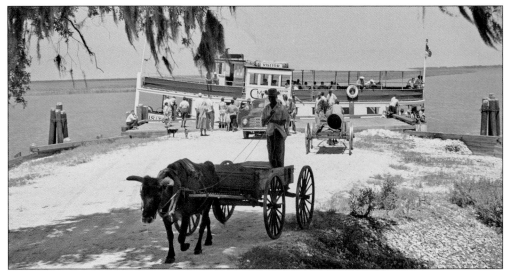

The *Visitor* was the first vessel owned by Capt. Samuel Stevens (1911–1992) and his partners, Dr. Henry M. Collier Jr. and Dr. Stephen McDew Jr. Their C.M.S. Savannah Steamship Line (later named Cap'n Sam's Cruises) purchased the 42-year-old, 68-foot, 125-passenger boat in 1952 from the Circle Line of New York. Island residents boarded the *Visitor* for shopping, visits to family and friends, and doctors' appointments. Excursions to Daufuskie for Savannah tourists featured picnic lunches of deviled crab, fried fish, fried chicken, boiled shrimp, red rice, potato salad, soda, beer, and moonshine. (Constantine Manos.)

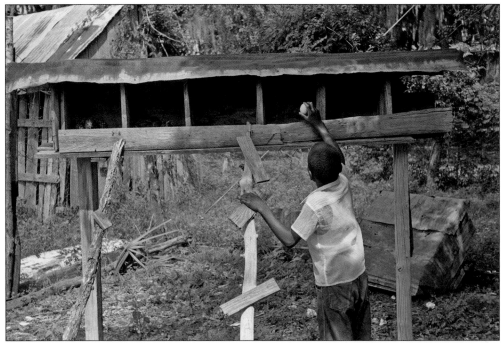

Collecting eggs from the chicken coop, raised high to keep away troublesome critters, is among this young boy's daily chores. On the day this photograph was taken, he also harvested a bushel of potatoes from the garden, fed the chickens and turkeys, tended to the horse, and chopped and stacked wood for the stove. (Constantine Manos.)

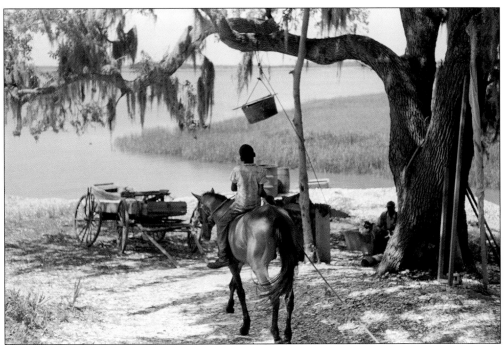

In the 1940 census, Franklin (b. 1897) and Geneva Miller (b. 1903) are listed as having two children: Anna Mae (b. 1933), and Edward (b. 1934). Franklin was a crabber and a laborer with the Works Progress Administration. This young boy, possibly a member of their extended family, lived with the Millers in 1952, helping in the house, in the yard, and out on the water. He is seen here riding the family horse back to the waterfront to retrieve the day's catch. Crabs were caught on baited lines or with hand-knotted nets while shrimp were caught with cast nets. Bottom-feeders like croaker and whiting were caught by "hook-a-line," a spool of cotton twine wound on a stick with hooks and weights and then cast as far as the line could be thrown. (Both, Constantine Manos.)

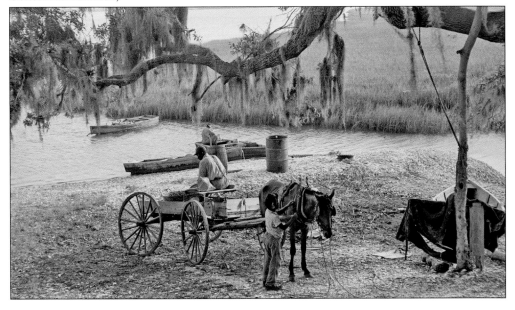

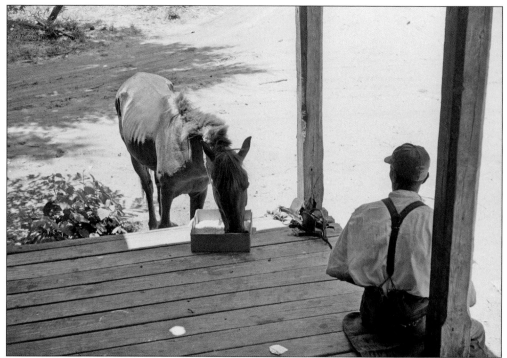

On Daufuskie, horses, cows, bulls, and oxen were part of family life and essential for island transportation. They were ridden, often bareback, and hitched to wagons for hauling wood, household supplies, or fishing equipment. In the garden, they were tethered to walking plows to turn the soil. Cows grazed, keeping the grass down, and were brought into the fenced yard at night to protect them from hunters. (Both, Constantine Manos.)

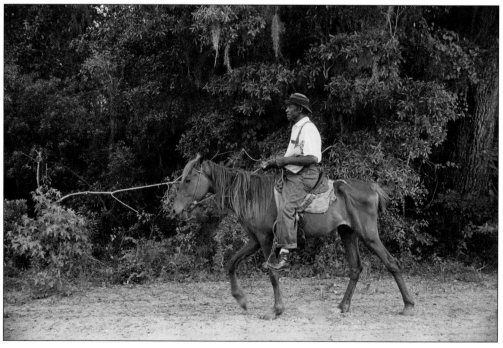

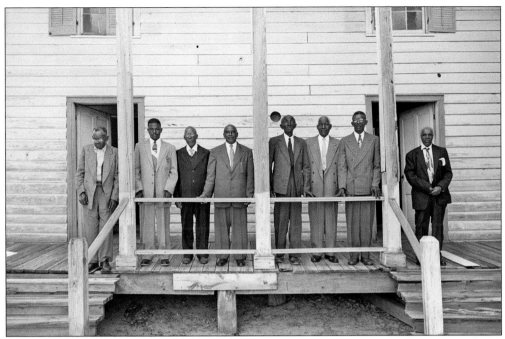

The First Union African Baptist Church was built in 1881 and rebuilt in 1884 after it was destroyed by fire. Standing at the entryway are, from left to right, deacons Henry "Lexie" Hamilton, Joseph "Uncle Cooley" Grant, Moses Ficklin, unidentified, John Bryan, Joseph Grant Sr., Isaiah Graves, and a visiting pastor. The church leadership was central to family life, providing guidance and direction. Sarah Hudson Grant would "catch a fire" in the wood stove to warm up the church before the congregation arrived. Men used the door on the left; women used the door on the right and were seated accordingly. (Both, Constantine Manos.)

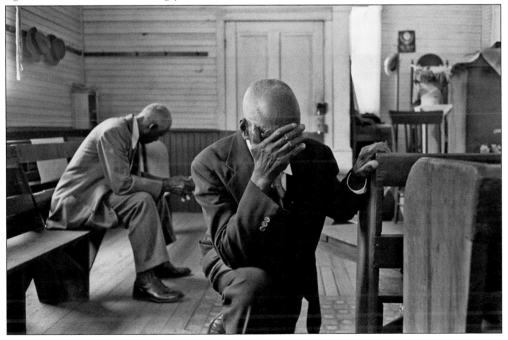

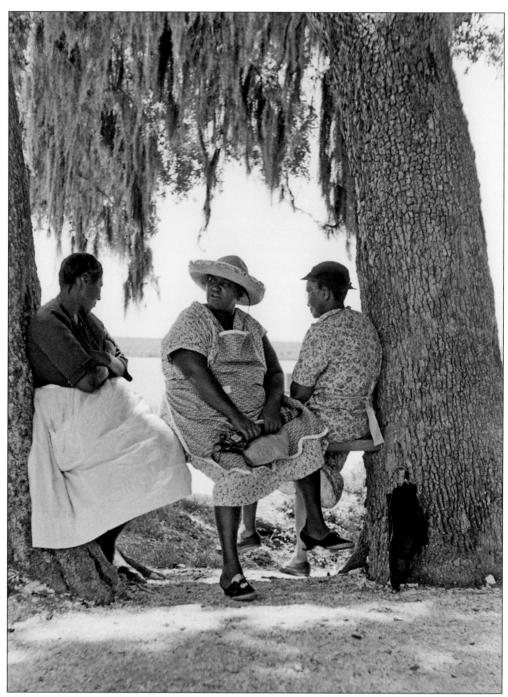

Louvenia "Blossum" Bentley Robinson (1897–1982), Viola "Ola" Bryan (1907–1969), and Sarah Hudson Grant (1888–1977) sit on a bench between the trees by the dock at the public landing. Wearing aprons to protect their clothing, they had folded their umbrellas after a walk in the sun. All were community-minded and participated in activities connected with the First Union African Baptist Church, the Mary Field School, benevolent organizations including the Union Brothers & Sisters Oyster Society, and presidential, state, and county elections. (Constantine Manos.)

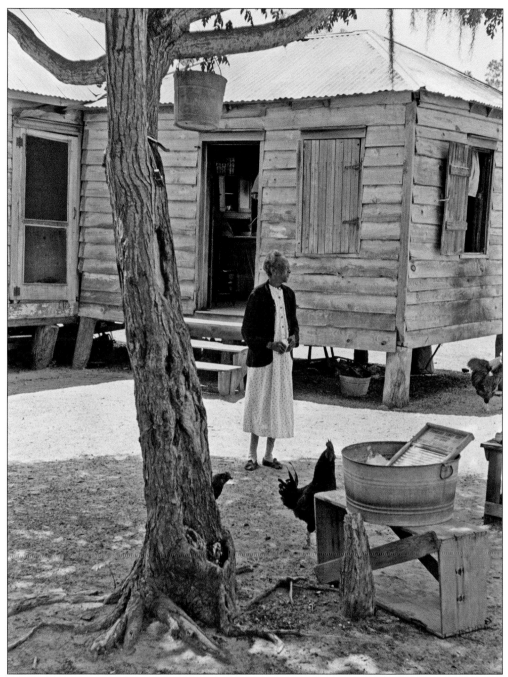

Houses built from the late 1800s through the 1930s were constructed by island craftsmen, with porches, indoor plumbing, and electricity installed later during times of economic prosperity. Most homes were tin-roofed and one story, raised from the ground by oak tree stumps. Wooden shutters kept out the weather. Interior walls and ceilings were often lined with brown paper for insulation. Yards were fenced to contain cows and horses and to keep animals away from the garden, fruit trees, and grape arbors. Water pumps were located outside, as were outhouses and storage sheds. Chickens roamed the yard while the laundry was washed and dried. (Constantine Manos.)

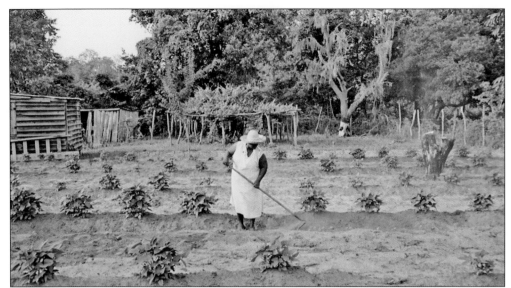

Viola Bryan planted an extensive garden and tended the grape arbor and fruit trees in her yard. A Daufuskie garden often included butter beans, okra, collard greens, peas, potatoes, and a variety of melons. Pear, peach, plum, and mulberry trees and arbors of scuppernong grapes provided fruit for canning and homemade wine. Chickens, hogs, and cows provided eggs, meat, milk, and butter. Any surplus food that was grown or raised was sold in Savannah. (Constantine Manos.)

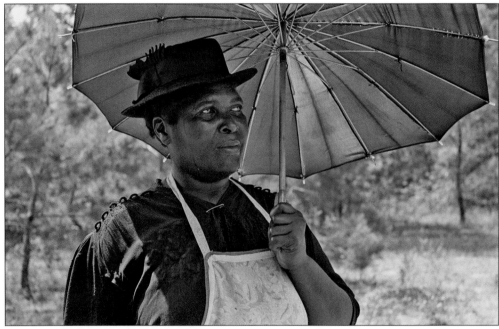

Estelle "Stella" Green Hamilton (1900–1978) shields herself from the sun with a large umbrella. Born on Daufuskie, her parents were Richard Green (b. 1849), who worked as a day laborer, and Mary Green (b. 1866), who in 1930 was a widow working as a servant in a private home. Miss Stella and her husband, William "Donkey" Hamilton, both oyster workers, had five children. In 1975, the Hamiltons bought one of three pre-fabricated homes that were barged to the island through the Farmers Home Administration program. (Constantine Manos.)

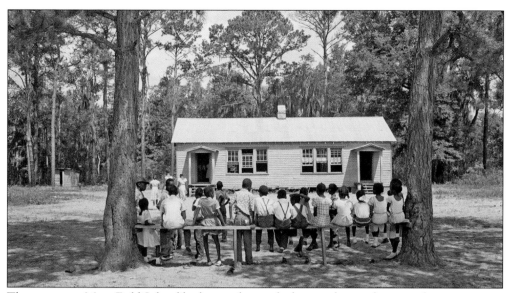

The two-room Mary Field School had a wood stove for heat and an outhouse and water pump in the yard. Playground games included hopscotch, tag, tug-of-war, guessing games, and ring games like "'Round the Mulberry Tree" and "Little Sally Walker": "Little Sally Walker, sittin' in a saucer. Ride, Sally, ride. Wipe your weepin' eyes. Put your hands on your hips, and let your backbone slip. Then you shake it to the east, and you shake it to the west, and shake it to the very one that you love the best." (Constantine Manos.)

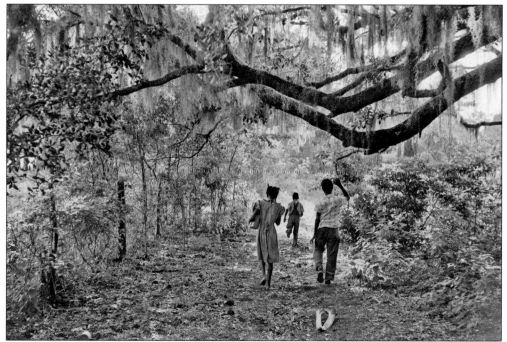

After school and when chores were finished, Daufuskie children found time to clamber up the timber company's pulpwood piles, climb trees, take shortcuts through the woods, play games, visit neighbors, chase after loose cows, hunt squirrels, roam through the old oyster factory, and take a walk down the road. (Constantine Manos.)

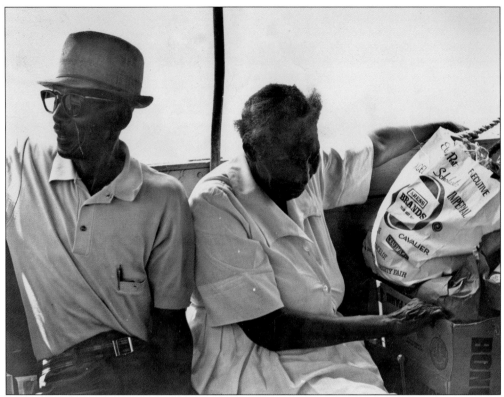

Isaiah Graves, a church deacon and oyster worker, sits with Louvenia "Blossum" Robinson on the ride back to Daufuskie from a shopping trip to the mainland. Staples like rice, grits, sugar, spices, evaporated milk, molasses, canned goods, bleach, and kerosene were purchased at Messex Grocery Store on the corner of Calhoun and Bridge Streets in Bluffton or at Food Fair in Savannah. Shoes were bought for children by measuring the foot of each child with a piece of string and taking the string to the shoe store. (Pat Conroy Archive, Irvin Department of Rare Books and Special Collections, University of South Carolina Libraries.)

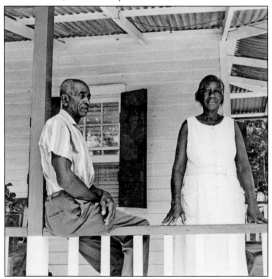

William "Hamp" Bryan (1902–1984), a dredge worker, and Sarah "Edna" Bentley Bryan (b. 1901), an oyster worker, rest on their porch on what is now Bryan Road, where they lived together for almost 50 years. Miss Edna sang in church and at community events. In 1965, when the Daufuskie Island Community Improvement Club was founded, William Bryan was co-chairman and served as chairman from 1969 through 1984. In their yard they raised cows, chickens, and hogs and grew vegetables, sugar cane, plums, and grapes. The Bryans had a temperamental horse named Dell that was not fond of children or the color red. (Daufuskie Island Historical Foundation.)

In 1962, Gene Burn (b. 1948), age 13, walks in front of the Daufuskie School. Standing on the porch are his teacher, Lola S. Merritt, and Henry Emmett McCracken, superintendent of the Beaufort County School District. From 1959 until 1962, Burn was the only student in the one-room schoolhouse that was built for white students in 1913 (though he was joined briefly by Gary Williams during his first year). Burn walked to school often carrying his gun to hunt for squirrels along the way. Merritt first came to the island in 1948 to teach then-six-year-old Gerald Yarborough, the only student that year. (Lancy and Emily Burn.)

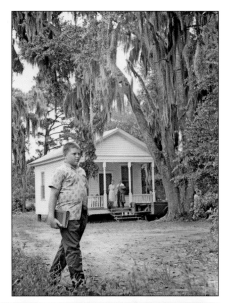

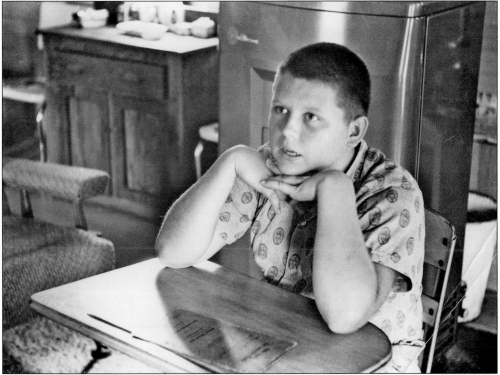

While teaching on the island, Lola Merritt made the Daufuskie School her home. She was provided with a kitchen in one corner and a two-seat outhouse and water pump outside. Surrounded by her personal belongings, there was just enough room for student Gene Burn's desk. Though he often brought his lunch to school, Burn remembers his teacher occasionally making pine bark stew. After graduating from the eighth grade, he attended Savannah Christian School and graduated with a class of 19. From there, Burn went on to attend the University of Georgia. (Lancy and Emily Burn.)

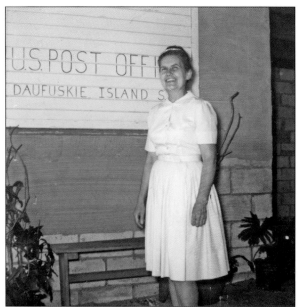

Billie Burn (1916–2008), seen here in 1964, took over the position of postmaster in 1963 and stayed on for 20 years. In 1967, she found three cadets from The Citadel wandering down a Daufuskie road after their Boston Whaler ran out of gas during a fishing trip from Charleston. Adrift for three days, they survived on three bottles of soda, four pieces of bread, and a jar of peanut butter. Burn picked them up in the school bus, radioed the mainland, and made them breakfast. Chief Deputy Sheriff G.J. DeBruhl accompanied the young men to Beaufort, where they were met by family and school representatives. (Daufuskie Island Historical Foundation.)

Doug Brown (left) and Alan Fisher (right) lived at the home of Viola Bryan in the spring of 1968. They were among the "California Boys" who came from the Cowell College Extramural Education Program from the University of California Santa Cruz (UCSC) to provide community service. Frank Smith explained, "John Rickford and I worked in the two-room elementary school; hoed gardens; patched roofs and mended fences; hauled groceries and supplies from the island boat to people's homes; started a youth program; and served as advocates for island people in their dealings with local, state, and federal agencies." The program was organized by John Herman Blake, founding provost of Oakes College at UCSC. (Daufuskie Island Historical Foundation.)

The *Miss Frances Jones* arrived at William Porter's dock on the New River in February 1968 with Capt. Robert Lewis at the helm. The first of three military-surplus boats given to the island community by the Beaufort-Jasper Economic Opportunity Commission, it ran daily between Daufuskie Island and Savannah, with occasional trips to Bluffton at no cost to residents. The *Strom Thurmond* arrived in August 1973 and the *Independence* in 1977. Beaufort County hired independent companies to run the pubic ferry starting in 1978. (Daufuskie Island Historical Foundation.)

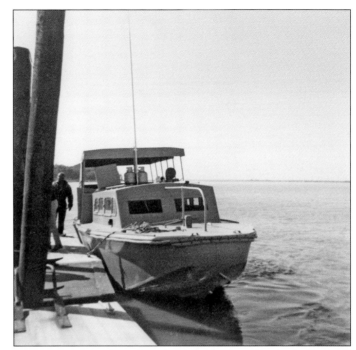

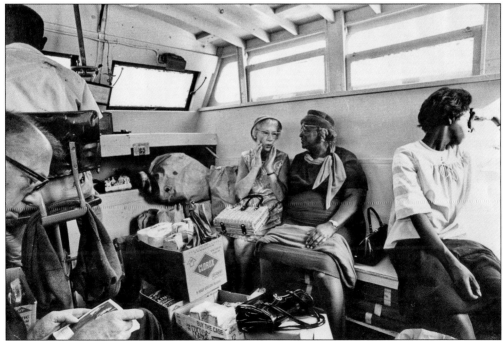

Captain Lewis pilots the *Miss Frances Jones* with passengers, including VISTA volunteers Henry and Rhea Netherton and Viola Bryan. Packed in cardboard boxes, groceries bought in Savannah or Bluffton were carried home by horse- or ox-drawn wagons. Children rarely made the trip to the mainland but would meet their parents at the dock to bring them home. Capt. Willis Simmons Sr. succeeded Captain Lewis with mates Thomas Stafford Sr. and Joseph Bryan. (Daufuskie Island Historical Foundation.)

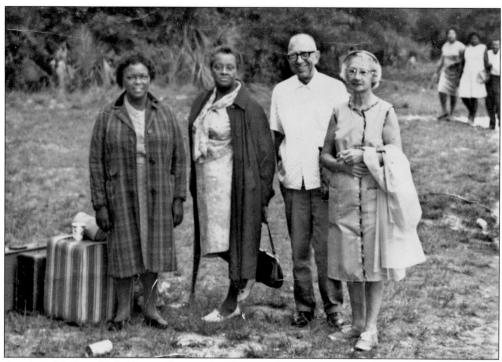

Annie E. McDonald (left), seen here with fellow teacher Frances Jones (1910–2002) and VISTA (Volunteers in Service to America) workers Henry and Rhea Netherton, taught fifth through eighth grade at the Mary Field School from 1965 through 1967. She and her nephew Ronald Sanders, a student at the Mary Field School, lived in the former Daufuskie School. Immediately after the Nethertons arrived in September 1965, Gov. Robert E. McNair insisted that they leave the state. In a telegram to Sargent Shriver, director of the Office of Economic Opportunity, McNair said of the VISTA volunteers, "We do not need them and we do not want them." (Paul Johnson.)

Governor McNair's decision to send Henry and Rhea Netherton away was ultimately reversed, and the couple stayed on Daufuskie for five years. In their 60s, they arrived from Berkeley, California, to work with island residents on community development and literacy projects. In 1968, they transformed Mount Carmel Church No. 2 into a community library with books and magazines loaned by the Beaufort County Library. While on Daufuskie, the Nethertons sent each child a birthday card with $1 enclosed and hosted Halloween parties at Mary Field School, complete with candy and costumes. (Daufuskie Island Historical Foundation.)

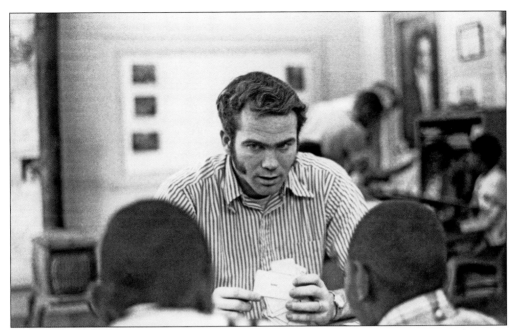

Pat Conroy (1945–2016) had been teaching at Beaufort High School, wanted to join the Peace Corps, and ultimately responded to a job opening for a fifth-to-eighth-grade teacher on Daufuskie Island starting in September 1969. Conroy said, "The way I teach makes it absolutely essential to make friends with the kids. They've got to be persuaded to talk to me. The first days, I'd get them up on their feet and have them talk about their best day fishing or hunting. In areas like that, I let them know that they could educate me." (Billy and Paul Keyserling.)

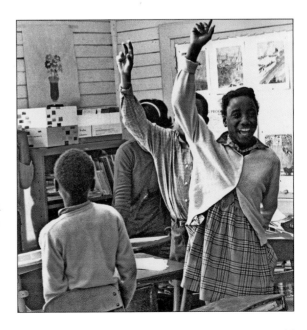

Sixth-grader Sallie Ann Robinson (b. 1958) raises her hand to answer a question posed by her teacher, Pat Conroy. In class, the students listened to Tchaikovsky, James Brown, and news on the radio that brought the outside world in. A favorite spelling word was "supercalifragilisticexpialidocious" from the movie *Mary Poppins*. During an interview, Conroy recalled, "We read poetry together. Most of them can now quote passages from Langston Hughes, E.A. Robinson, Alfred Noyes. They know the 50 states, the capitals, the countries of Europe, Asia, South America, and Africa. They have watched over 200 films ranging from the rise of Mussolini to a rodeo in Canada." (Billy and Paul Keyserling.)

Teaching on Daufuskie included chopping wood for the heater, picking up fresh milk (before Pat Conroy arrived, the students drank powdered milk), and conducting general building maintenance. On June 30, 1970, Conroy successfully defended himself before the Beaufort County school board against a proposal that he be fired as a teacher at the Mary Field School. The allegations included being late for school, commuting daily rather than living on the island, inappropriate charges for boat fuel, and not working within the chain of command. In the audience were friends, family, and three parents of his Daufuskie students who hand-delivered a petition in support of Conroy that was signed by island residents. (Billy and Paul Keyserling.)

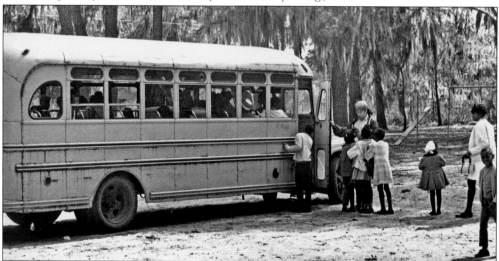

In April 1974, a group of 29 Daufuskie residents, including eight of Conroy's students, traveled to Beaufort to see the premiere of *Conrack*, the movie, starring Jon Voight, based on Conroy's memoir *The Water Is Wide* (1972). Some were uncomfortable about their on-screen characters and felt exploited by their inclusion in the book. About the book and the movie, Conroy said in a 1977 interview, "I had no idea what it would do to the sanctity and privacy of the island. Since then I have just tried to stay away. I feel like I have done enough to the island." (Billy and Paul Keyserling.)

During the fall of 1970, at the beginning of his second year teaching on Daufuskie, Pat Conroy was fired for "insubordination." Supt. Walter Trammel, who initiated Conroy's dismissal, said in an interview, "I don't object to Conroy's teaching methods—I think they're wonderful. . . . But he ignored school board policies. . . . He's got to learn there's somebody in the world besides himself." The island community rallied in support of their teacher, but were unable to change the school board's decision. Louvenia "Blossum" Robinson said, "I born here and my daddy and grandaddy born here, and I say we ain't never had a teacher like this man." (Billy and Paul Keyserling.)

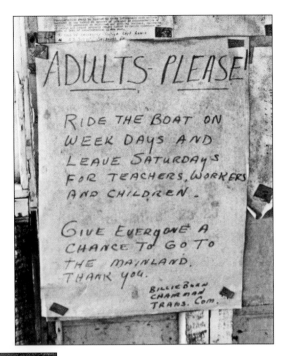

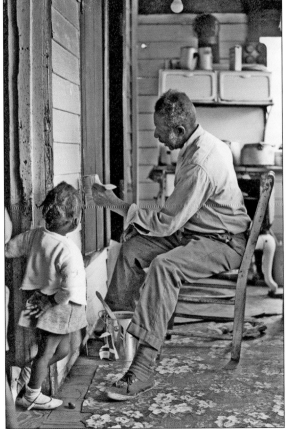

Josephus Robinson (1900–1997) was one of 16 children in his family born on Daufuskie Island. He had six girls of his own with his wife, Louvenia "Blossum" Robinson. After years of work on a dredge boat out of Savannah, he farmed, hunted, fished, tended to his animals, and made moonshine. Performing routine maintenance, Robinson paints his porch as a little one looks on. (Billy and Paul Keyserling.)

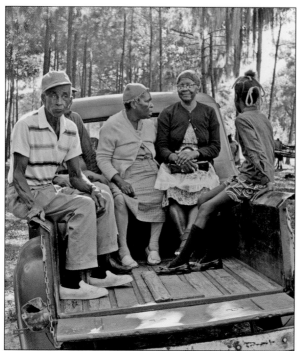

Pictured from left to right, William "Hamp" Bryan, Estelle Hamilton, and Geneva Wiley travel by truck across the island. When trucks and cars began replacing ox and horse carts, the pace and ease of travel changed considerably. Motor vehicles provided convenience and protection from the elements. Though sources of fuel were limited, there were many amateur mechanics available should a vehicle need repair. In 1970, Billy and Paul Keyserling visited Daufuskie during their spring break to take photographs and record interviews for a college project. Some of the pictures are included in the early editions of *The Water Is Wide*. Billy went on to be elected mayor of Beaufort, and Paul is a photographer and professional videographer. (Billy and Paul Keyserling.)

Frances Jones sits by Sarah Hudson Grant at the Mary Field School in 1968. Miss Frances was the only one of Isabel Holmes and Rev. James Joneses' seven children to survive beyond their early years. She was raised on Daufuskie by her grandparents, Joseph (b. 1860) and Margaret "Peggy" Gibson Mikell (1865–1963); her great-grandfather, Thomas Mikell (b. 1830), lived with them as well. After fourth grade, Miss Frances was sent to Savannah, where she completed high school at age 15 and, in 1942, earned a degree from Savannah State College. Miss Frances was the first president of the Daufuskie Cooperative and served on the board of the Daufuskie Island Community Improvement Club. (Daufuskie Island Historical Foundation.)

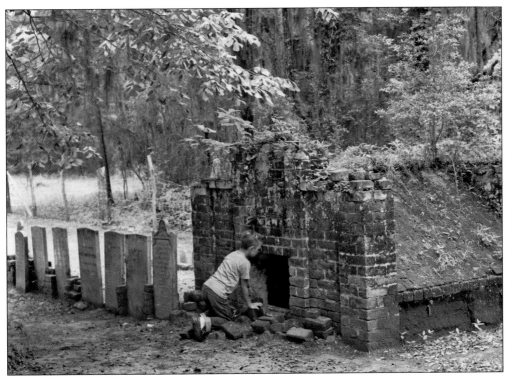

Mary Dunn Cemetery is a four-acre parcel on Mungen Creek that was a part of the 300-acre plantation called Prospect Hill, owned by Mary Martinangele Dunn (1785–1878). She was the daughter of Isaac and Mary Martinangele and the wife of Francis Dunn, who passed away in 1823 at age 46. All four are interred in the family burial ground. As late as the 1970s, cast-iron caskets with glass faceplates could be seen in the now-bricked-in tomb. Such caskets—Fisk's Metallic Burial Cases—were patented by Almond Dunbar Fisk in 1848. (Daufuskie Island Historical Foundation.)

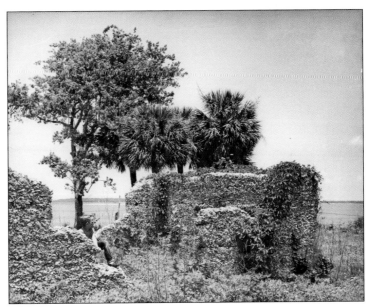

George Herbert "Pete" Bostwick (1909–1982) preserved the remains of the tabby slave quarters and renovated the lighthouse after he purchased Haig Point in 1961 from Stiles Harper of Estill, South Carolina. Bostwick's horse Daufuskie won the Holly Tree Hurdles Handicap at Delaware Park in 1968 that paid $5.20 for every $2 bet. (Daufuskie Island Historical Foundation.)

The oldest headstone in Maryfield Cemetery marks the grave of Jacob Hudson (1890–1918), who grew up on Daufuskie and served in World War I. In the 1920s, Planters Mercantile in Bluffton supplied coffins to Daufuskie's black residents. Albert Ullman, the shop owner's nephew, recalled, "I can remember . . . the knocking on the door in the middle of the night. . . . They came to buy a casket. . . . The boat was small and they would position the casket crossways so that they could hold on to it to go back to Daufuskie Island, so it shouldn't fall into the water." (Pat Conroy Archive, Irvin Department of Rare Books and Special Collections, University of South Carolina Libraries.)

Five

1970s–1980s

Worldwide attention was drawn to the economic and educational challenges on Daufuskie following the 1972 publication of Pat Conroy's memoir *The Water Is Wide* and the 1974 movie *Conrack*. After Conroy was fired, he was followed in quick succession by teachers Michael McEachern, Frank Smith, Robert Thompson, Howard Johnson, and John Marks. James and Carol Alberto taught at the Mary Field School from 1974 through 1983 and gained accreditation for the school during their tenure. Four white students enrolled in 1981, integrating the school.

In 1972, telephone service was made available to islanders and real estate developer Charles Cauthen made his first visit. The Daufuskie Island Cooperative store, funded by the Catholic Bishops' Campaign for Human Development and the Beaufort-Jasper Comprehensive Health Services program, opened in 1975 when the island population included approximately 100 black and 10 white residents. In 1976, Frances Jones helped found Daufuskie Day as an annual homecoming celebration to preserve island traditions and honor the legacy of the island's slave descendants.

In 1978, a pavilion was built at the public landing, and a 2,700-acre state park was proposed but never materialized. In 1979, Haig Point was purchased from the Bostwick family by Charles Cauthen's Daufuskie Island Land Trust investment group. The first UPS delivery was made in 1981. In 1982, the National Park Service listed Daufuskie in the National Register of Historic Places; the first medical clinic opened; and Alex Haley visited the island then wrote an article for *Smithsonian* magazine titled "A Sea Change on Daufuskie Island," describing an island culture suspended in time yet threatened by development. In 1984, Beaufort County established a zoning code for Daufuskie that encouraged the preservation of neighborhoods, historic sites, and open space, while laying the groundwork for development on the island's privately held tracts. Also in 1984, the Melrose Company purchased the oceanfront Melrose property and International Paper Realty Corporation purchased Haig Point. In 1986, the historic Strachan mansion was barged from St. Simons Island, Georgia, for use as a gathering place for Haig Point members and guests. Jimmy Buffett drew attention to development on Daufuskie with his Pat Conroy–inspired song, "Prince of Tides," written in 1988, the same year that the Melrose Company purchased Bloody Point.

Longtime island resident Francis Burn suggested that the island needed "sardine and cracker type people, not caviar and champagne people." Sarah Hudson Grant worried about the community losing its connection to the past but was resigned to the notion that sometimes "you have to lose something if you want to gain something."

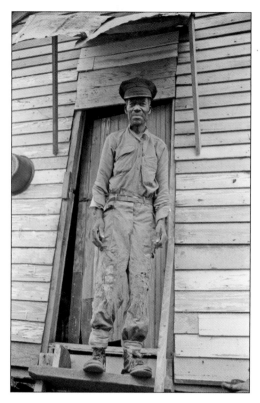

Richmond Wiley (1895–1972) was a life-long collector. He gathered items washed up on shore or floating in surrounding waters, storing useful items in the shed that he built by his house. Having worked on a dredge boat for the US Army Corps of Engineers, Wiley was employed as "commodore" of the Savannah Harbor in 1955, working five days a week for more than 10 years. He was paid $216 per month to clear driftwood with his small wooden rowboat to create safe passage in the waterway. He said, "I hunt them like a dog hunts a rat," adding, "it's cold in winter . . . and when it rains I just hole up under a dock somewhere." (David Morrison.)

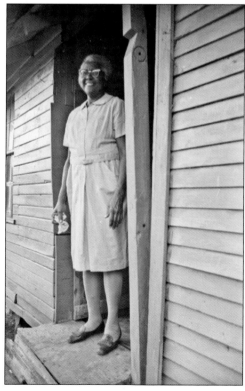

Geneva Wiley (1903–1995) stands on the porch of the clapboard house that her husband, Richmond Wiley, built shortly after their marriage. She was the mother of 10 children and had 18 grandchildren, 28 great-grandchildren, and six great-great-grandchildren. In 1979, at age 76, Miss Geneva, along with 100 other island residents, braved Hurricane David, disregarding the evacuation order. "I've lived all my days on Daufuskie," she said, "and I been in many storms and they never has done anything bad. I'm trusting in the Lord. He will carry me on." Those who stayed came through unharmed. (David Morrison.)

Maybell Williams Jenkins (b. 1928) lived all her life on Daufuskie Island. She was married to Lawrence Jenkins (1924–2005) and was the mother of 11 children: Jerome, Lawrence Jr., Ronnie, Stanley, Charles, Barbara Ann, Lenora, Eva Mae, Laura, Rebecca, and step-daughter Lou. Miss Maybell was the Mary Field School PTA treasurer in the 1960s. Lawrence Jenkins attended school at the Mount Carmel Baptist Church (Cooper River School) and Mary Field School, was a seaman in the US Navy, a World War II veteran, a deacon and trustee of the First Union African Baptist Church, and served as treasurer of the Daufuskie Island Community Improvement Club. (David Morrison.)

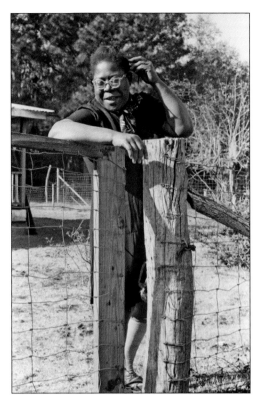

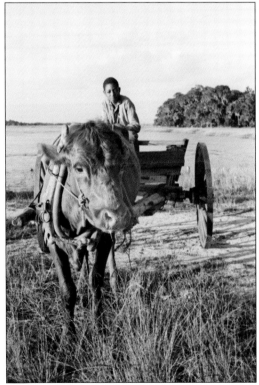

David Robinson (1959–2001), who had a twin brother Isaac (1959–2009), sits on a wagon pulled by John, an ox that belonged to his grandmother Louvenia "Blossum" Robinson. Starting at a young age, children were responsible for the care and feeding of the family animals. They learned to ride horses and cows and hitch them to two- and four-wheeled carts for transportation around the island, hauling firewood, and picking up groceries and supplies from the dock. (David Morrison.)

Johnnie Hamilton (1906–1988) was an oyster worker and a member of the Union Brothers & Sisters Oyster Society. He helped disassemble and move the Chaplin house that became the Oyster Society Hall in 1921. Hamilton went to the Cooper River School as a child with teacher J.D. Gaston, became a deacon at the First Union African Baptist Church, assisted with baptisms in the Cooper River, played Santa Claus at the community Christmas party in 1970, and met author Alex Haley when he visited the island in 1982. (David Morrison.)

The 1930 and 1940 census records for the household of Thomas Bryan Sr. (1888–1980) include his mother Maggie (b. 1859), his wife Georgia Rice Bryan (b. 1894), and children Thomas Jr., James, Cleveland, Nathan, Wilhelmina, Margaret, Cecelia Ann, and Georgia Mae. A son, William, was already deceased. Bryan Sr. was a dredge worker and laborer during the partial demolition of the Cockspur Island quarantine station (opened in 1891) and the restoration of Fort Pulaski (designated a national monument in 1924). In 1965, he was the head of the Ways and Means Committee of the Daufuskie Island Community Improvement Club. (David Morrison.)

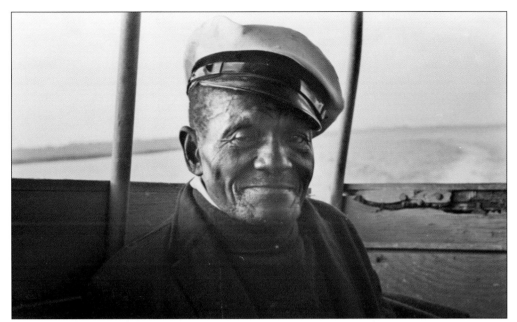

On a monthly shopping trip, Walter "Plummy" Simmons Sr. (b. 1900) travels by boat for the hour-long ride to Savannah. Simmons and his wife, Agnes Mitchell Simmons (1903–1998), lived at the north end of the island. In the 1940 census, Simmons is listed as a watchman at a summer resort. He farmed, fished, and hunted to provide food for his family. (David Morrison.)

Walter "Plummy" Simmons sits up high on a new John Deere tractor provided by the Beaufort-Jasper Economic Opportunity Commission. A life-long farmer, Simmons was responsible for turning up the community's garden plots, offering an alternative to the cow- or horse-drawn plow for preparing the ground for planting. In 1918, Simmons farmed acreage at the Cooper River Plantation for Seacoast Farm Company of Savannah, which provided all supplies, including seed, fertilizer, and mules. (David Morrison.)

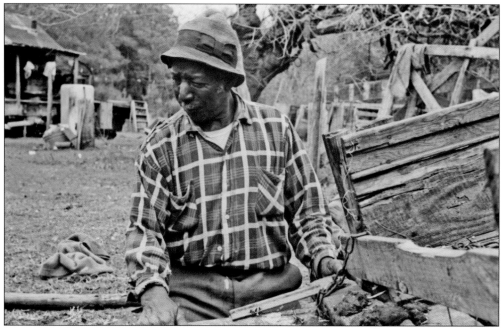

Josephus Robinson repairs a wagon in his yard. He was a man of few words who shared his time and helped neighbors whenever he could. As a young man, he worked on a dredge boat in Savannah and "earned a dollar a day from sun up to sun down." Robinson recalled that when he was growing up, he could walk across the Calibogue Sound from Daufuskie Island to Hilton Head at low tide. (David Morrison.)

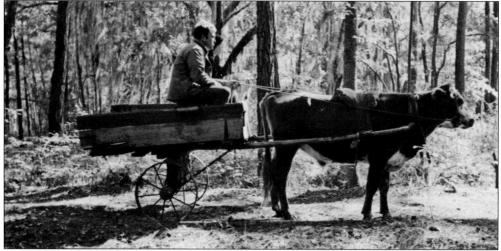

Tim Biancalana drives a two-wheeled wagon pulled by Albertha Robinson's ox, Bobby. Biancalana arrived on Daufuskie with David Morrison in September 1970 from the University of California Santa Cruz. Morrison brought his camera to document his experience. Working on community projects, these "California Boys" stayed at the home of Frances Jones until their departure after Christmas. Other participants who stayed with Viola Bryan included Larry Robinson and Randy "R.J." Rice (fall of 1968), Zachary Sklar and Ed Flaherty (winter of 1969), Mitchell Page and Dan Hammer (spring of 1969), Jim Ford and Joe Sanfort (fall of 1969), Chuck Hafley and Allen Carlson (winter of 1969), and John Rickford and Frank Smith (spring of 1970). (David Morrison.)

In the late 1970s, cars and trucks began replacing wagons pulled by draught animals. In August 1978, a two-vehicle accident on Daufuskie was reported in local and regional newspapers. Fortunately, no one was hurt. The number of motor vehicles on the island had recently risen from eight to 15. Years before, an accident occurred on Christmas Eve in 1951 when the only two motor vehicles on the island, trucks driven by Fred Dierks and William Brabham, collided. One passenger was injured and both trucks were severely damaged. The rusty frames of several old Fords remain on the island today. There was no public rubbish removal from Daufuskie until 1990. Household garbage was either buried, burned, or piled away from the homes. Larger items like the car and truck seen here in 1970, were abandoned and left in the woods. Driver's licenses, license plates, and vehicle registrations were not required on Daufuskie until the mid-1990s. (Both, David Morrison.)

The boarded-up building in the background, seen here in 1970, is the store that Gustaf Ohman built in 1912 that was called Sheppard's Luck in 1952. Tracks from wooden ox-cart wheels and car tires can be seen in the sandy road. With unnamed roads, these signs, located at what is now the intersection of Haig Point and Benjie's Point roads, pointed the way to primary destinations on the island. (David Morrison.)

With a sign reading "Inquire Next Door," this house was available for rent in 1970 on what is now called Martinangele Road. The house, valued at $500 in the 1930 census, was built in 1926 and owned by James Bentley (b. 1879), a farmer and dredge worker, and his wife, Amelia Bentley (1885–1961), an oyster worker. They had three daughters: Viola, Josephine, and Helen. Richard Lahr built a workshop for his Daufuskie Woodworks after purchasing the property in 1986. The house was renovated to include modern conveniences but maintains the character of homes built on Daufuskie over 100 years ago. (David Morrison.)

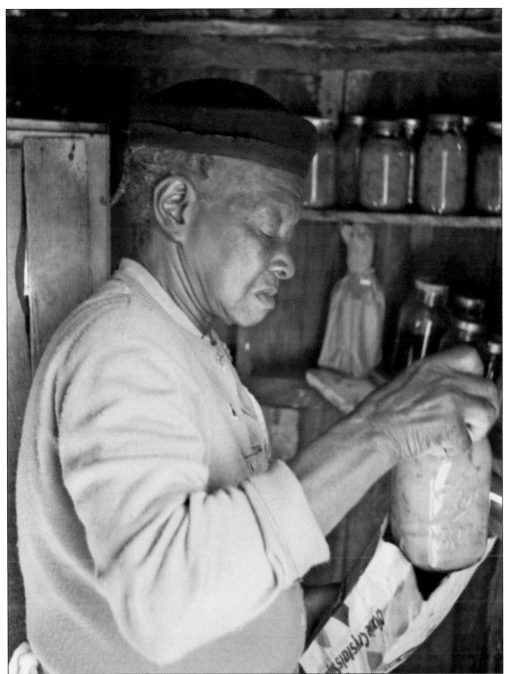

As one of 10 Daufuskie midwives, Sarah Hudson Grant delivered more than 130 babies from 1932 through 1969. An active participant in island affairs, she was a member of the PTA and walked great distances to attend community meetings using a small branch from a chinaberry tree as a cane. In the summer months, Miss Sarah canned homegrown okra, tomatoes, peaches, and pears that lined the shelves of a storage room by her back door. She used an empty Dixie Crystals sugar bag to protect a mason jar of preserves from the sunlight. In her younger days, she worked as an oyster shucker and in the orchard at Melrose Plantation. (David Morrison.)

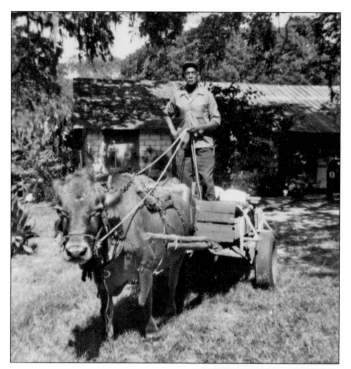

Johnnie Hamilton lived at the north end of the island by the Mount Carmel Baptist Church. In 1983, he was interviewed by Vertamae Smart-Grosvenor for her award-winning radio documentary "Daufuskie: Never Enough Too Soon" for National Public Radio's *All Things Considered.* With prompting by Smart-Grosvenor, Hamilton sang, "Farther along we'll know all about it. Farther along we'll understand why. Cheer up, my brother, live in the sunshine. We'll understand it all by and by." (Daufuskie Island Historical Foundation.)

James Williams was a lifelong resident of Daufuskie. He had trouble walking, so he relied on his animals to get around. Williams had an ox and a horse that he rode bareback or hitched to pull his wagon. Mailboxes were placed high on poles to allow those driving their wagons to stay seated while mailing letters. Island artist Christina Roth Bates created two hand-painted etchings featuring Williams on a wagon with his white ox. (Daufuskie Island Historical Foundation.)

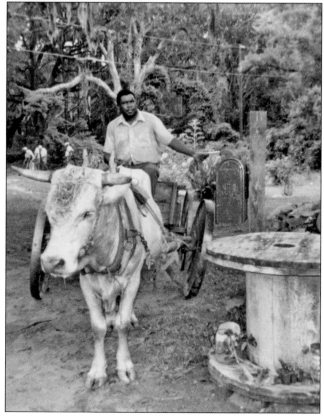

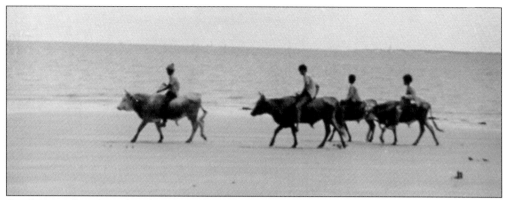

Cattle were found in abundance on the island starting in the 1700s when there was plenty of pasture and a market for beef and hides. Little labor was required and no fencing was needed. As the population fluctuated after the Civil War, so did the number of livestock on the island. From the 1950s through the mid-1980s, most families kept a cow for milk, hogs for meat, and horses and oxen for transportation and work in the garden. For boys on Daufuskie, having one's own bull was a rite of passage. When the family cow gave birth, the first male calf was given to the eldest boy and so on down the line. (Bill Boyd.)

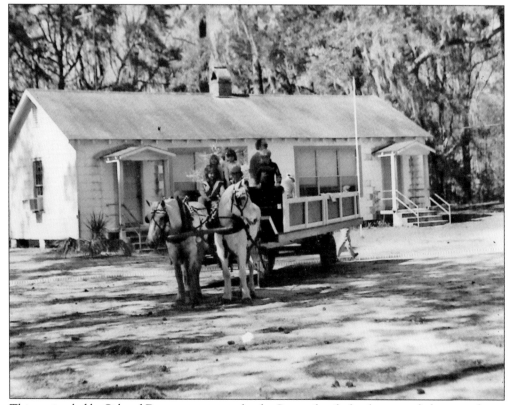

This outing led by Sid and Dan was a test run by the Scurry family for the start of a horse-and-cart tour of the island from the Cooper River Landing. Unfortunately, the ride proved to be too slow to get to the beach and all of the historic sites, including the schools, churches, cemeteries, and lighthouses. The tour company decided to use old school buses for more efficient travel around the island. (Wick Scurry.)

As a commercial shrimper, Francis "Bud" Prevost Bates (1944–2007) frequented the waters off Bloody Point in his round-stern shrimp boat, the *Finest Kind*. Responding to a newspaper ad, he became the first manager of the Daufuskie Island Cooperative store in 1975. Located at the public landing, the store was built by students at the Beaufort Technical Education Center (now the Technical College of the LowCountry) with a $19,900 grant from the Catholic Bishops' Campaign for Human Development. Beaufort-Jasper Comprehensive Health Services contributed $2,000 to stock the store, with Bates transporting provisions from the Jenkins Island landing. The Comprehensive Employment and Training Act funded his position and that of sales clerk Edvina Washington. (Christina Roth Bates.)

William "Willie" Miller was known for his generous spirit and exceptional strength. He cut and hauled wood and could easily lift 55-gallon drums filled with fuel. Miller was also very quiet. While spending time at Bud Bates's house, he rhythmically picked up and flicked over the fence cigarette butts that had collected in the yard. For Sallie Ann Robinson and her sisters, Linda Marie and Lois Fay Stafford, Miller pulled down the hard-to-reach branches of chinquapin trees for the girls to pick the acorn-like nuts. They used a needle and thread to make edible necklaces. (Christina Roth Bates.)

Following the departure of Henry and Rhea Netherton, VISTA volunteers James and Vivian Strand arrived from Michigan and stayed on Daufuskie from 1969 until 1971. They helped students at the Mary Field School, visited island residents, and hosted flea markets. Vivian Strand acted as a substitute teacher when Pat Conroy was absent. The Strands also assisted with an outreach program led by the Beaufort County Library called the "Disadvantaged Project." Librarian Betty "Jett" Ragsdale traveled by boat from Bluffton twice weekly for three months. She read stories, and the Strands showed filmstrips, including *Stone Soup*, *John Henry*, *The Story about Ping*, and *The Red Carpet*. (Beaufort District Collection, Beaufort County Library.)

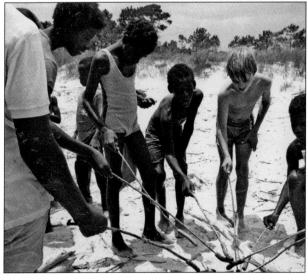

The Beaufort County Library hosted a hot dog roast at the beach with grape Kool-Aid and chocolate cupcakes to celebrate the end of their three-month enrichment program. In addition to the story hour, the library gave the children books to take home and provided crab nets for the older boys as part of the Neighborhood Youth Corps that offered students jobs in 1971. Deemed a success, the library program continued during the summer of 1972. (Beaufort District Collection, Beaufort County Library.)

In August 1978, a pavilion and public restrooms were built next to the Daufuskie Island Cooperative store, funded once again by the Catholic Bishops' Campaign for Human Development (approximately $32,000) and Beaufort-Jasper Comprehensive Health Services. A commercial kitchen was built, intended for use by islanders to prepare food, particularly deviled crab, to sell to tourists when they disembarked at the public landing. The concept failed leading Beaufort County to lease the property to restaurants beginning in 1980 including: Remy's, Ujima's, Changes, Marker 39, and Terri's Downtown Bar & Grill. Beth Shipman brought Marshside Mama's to the pavilion in 1999. An island institution, Marshside Mama's closed on January 1, 2018. (Daufuskie Island Historical Foundation.)

In 1973, Frances Jones drove a green Dodge Colt sedan. As a young child, she had fallen and injured her right leg. Her leg never healed properly, due to the injury or possibly polio. Her grandfather Joseph Mikell handcrafted her first crutch, and her impairment never interfered with her mobility. Miss Frances was quoted as saying, "Being handicapped is a little inconvenient but it never kept me from doing what I need to do." The Frances Jones House, located across the road from the Mary Field School is still owned by her family; it has been restored by Preservation South Carolina and is available for rent. (Paul Johnson.)

A graduate of Louisiana State University and a medical officer in World War II, John Carroll "Dr. Jack" Scurry of Greenwood, South Carolina, bought 26 acres of riverfront property on Daufuskie from Capt. Samuel Stevens in 1976 and converted Stevens's nightclub into a family retreat. In 1984, the Scurry family built the Cooper River Landing marina as a day dock and later sold it to the Melrose Company, which would purchase Melrose and Bloody Point Plantations. (Wick Scurry.)

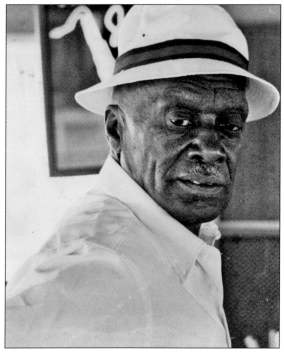

Jake Washington (1925–1996) made the first phone call from Daufuskie with Hargray Telephone Company's microwave transmission system when he dialed his daughter Lula Mae Lawyer in New York on June 12, 1973. Washington was married to Flossie Stafford Washington (1926–2014) and had 15 children. He was a mailman, school custodian, clammer, provider of island taxi and tour guide services, a dice-throwing enthusiast, and an expert maker of moonshine. Washington served as inspiration for poet Mari Evans after her visit to Daufuskie in the early 1970s. Evans wrote in her 1974 poem *Jake*, "Jake the best damn cap'n in the world / O gaaahd / the best damn cap'n in the world / just been running the boat / for the last twenty years / for the last twenty years / O gaaahd. . . ." (Wick Scurry.)

Sallie Ann Robinson graduated from the Mary Field School in 1970 after her seventh-grade year. After attending eighth grade in Savannah, she graduated from high school in Bluffton. Commuting to and from school on Mondays and Fridays, she stayed with family members off-island during the week. One year, she and other Daufuskie students lived in a boardinghouse, paid for by the Beaufort County School District, and were looked after by a couple who lived down the street. Inspired by her mother, Albertha Robinson Stafford (1928–2013), and grandmother Louvenia "Blossum" Robinson, Miss Sallie returned to Daufuskie in 1976 as an aide to teachers James and Carol Alberto and joined many of the island's civic organizations. (Sallie Ann Robinson.)

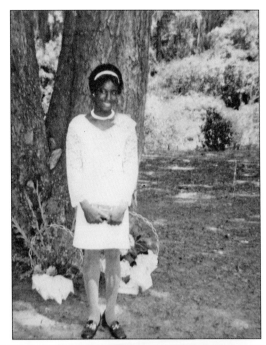

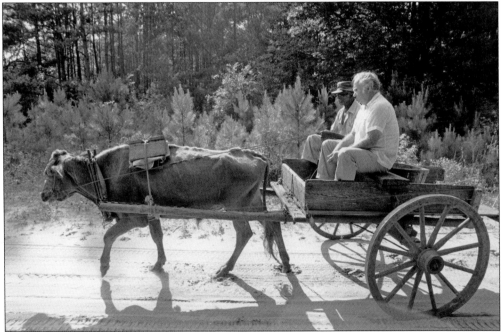

Josephus Robinson (driving) and Rev. Clarence L. Hanshew Jr. (foreground) ride on a Daufuskie road in a two-wheeled wagon pulled by John. Reverend Hanshew, director of missions for the Savannah River Baptist Association of Churches in Beaufort and Jasper counties, started visiting Daufuskie in 1967. The First Union African Baptist Church was closed periodically from the late 1950s through the late 1960s with occasional services held in the school buildings. Reverend Hanshew helped restart regular worship services and initiated the first vacation bible school for the children of Daufuskie, which has run every summer since 1968. (Daufuskie Island Historical Foundation.)

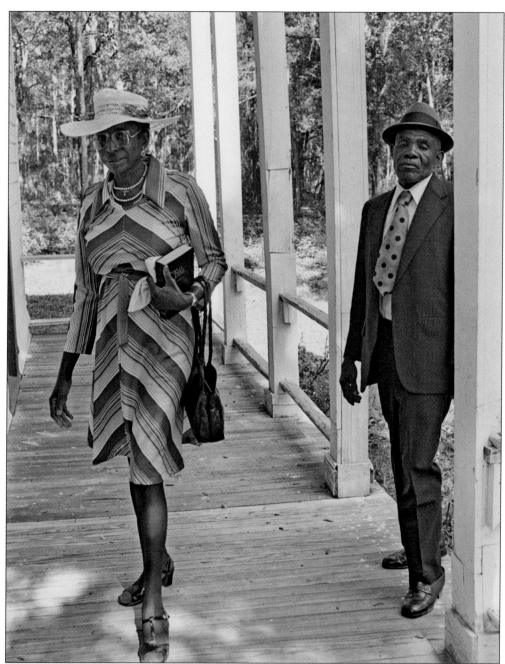

Albertha Robinson Stafford and Lawrence Jenkins stand on the porch of the First Union African Baptist Church in this photograph by Jeanne Moutoussamy-Ashe. Introduced to Daufuskie by film historian Donald Bogle and food writer and commentator Vertamae Smart-Grosvenor, Moutoussamy-Ashe stayed at the home of Susie Smith during her many visits to Daufuskie. Her images of Daufuskie and surrounding sea islands are published in the acclaimed book *Daufuskie Island: A Photographic Essay* (in 1982 and 2007), with a complete set of 61 prints donated by Bank of America to the National Museum of African American History and Culture in Washington, DC, in 2014. (© Jeanne Moutoussamy-Ashe.)

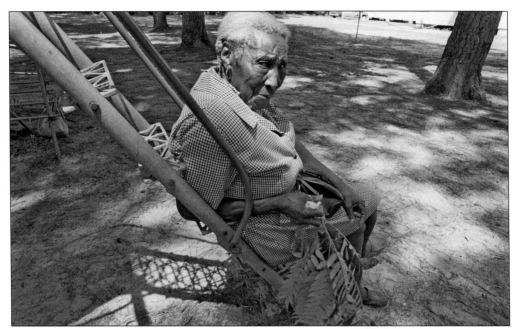

Louvenia "Blossum" Robinson sits on the steps of the slide at the Mary Field School playground, holding a leafy branch to keep the flies away. She cared for her garden and worked in her kitchen. Miss Blossum had fruit and nut trees in her yard and a hole dug in the dirt floor of her shed to serve as a root cellar. She often set her granddaughters to work on her butter-bean crop. They picked the pods from the garden vines, shelled them into a tin or onto a croker sack, and turned the beans as they dried in the sun; once dry, they were ready to cook or freeze. (© Jeanne Moutoussamy-Ashe.)

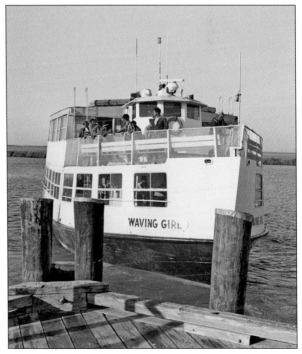

Born in 1911 in Darien, Georgia, Samuel Stevens was the youngest of 20 children. He worked with his father, a ship's carpenter, and for the US Army Corps of Engineers and the US Coast Guard. In 1952, he started Stevens Oil and the C.M.S. Savannah Steamship Line with two partners. The *Waving Girl*, purchased in 1966, was a lifeline for Daufuskie residents: groceries, ice, and supplies were transported from Savannah, Beaufort, and Bluffton. Stevens also brought mourners accompanying caskets for burial at one of the island cemeteries. Charters and moonlight cruises with dinner and dancing were offered seasonally. Captain Stevens ran a nightclub at Cooper River Landing from the early 1950s until 1976. (© Jeanne Moutoussamy-Ashe.)

In 1971, Bruce Davidson and Carol Hill were led by William "Buddy" Hudson on a two-day tour of Daufuskie while on assignment for a book funded by the Ford Foundation. Davidson captured images of the landscape; island residents, including Josephus Robinson and Sarah Hudson Grant; and children tending pigs, mending fences, riding in wagons, jumping rope, riding horses, and walking to school. Hill interviewed Flossie Washington and Frances Jones for *Subsistence U.S.A.*, published in 1973. Bruce Davidson is a noted and widely exhibited photographer and a member of Magnum Photos since 1958. Carol Hill Albert is an author and the former co-owner of Astroland Amusement Park on Coney Island. (Both, Bruce Davidson.)

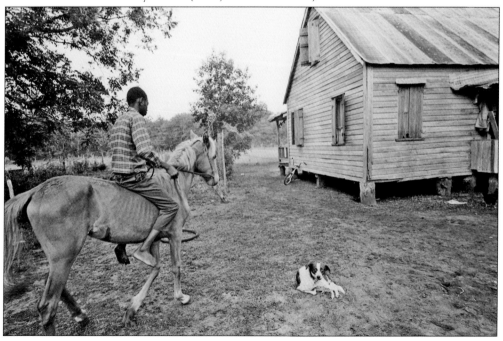

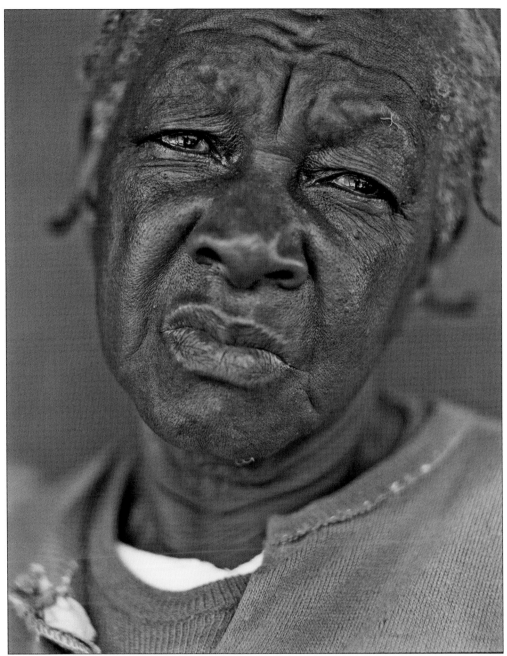

Sarah Hudson Grant was the last midwife on Daufuskie Island, retiring in 1969. She was born in 1888, the oldest child of William Hudson (b. 1870) and Alice Moore (b. 1866). Miss Sarah married Joseph Grant (1882–1962) in 1912, and they had a son named Louis in 1914. She took on an additional job as the island's last undertaker after the death of her husband. Miss Sarah expressed concern for the future of Daufuskie, saying, "The young, they leave, and they don't come home." (Bruce Davidson.)

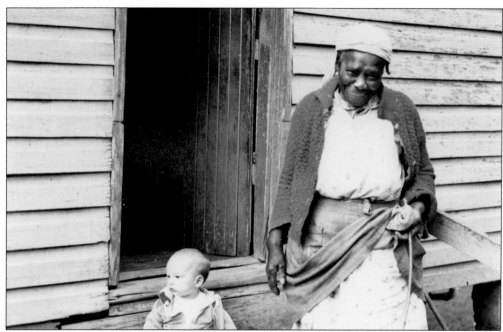

Lillie Mongin Simmons (1906–2007), seen here in 1988 with Joseph Hutton (b. 1987), worked as an oyster shucker, farmer, and community advocate. Her mother, Maggie Hudson Mongin, was freed from slavery in Albany, Georgia. Her grandfather, Bradley Mongin (b. 1840) was likely enslaved on Daufuskie. Married to Jake Simmons (1901–1977), she had four children: Eddie (1924–2010), Josiah (nicknamed "Sier," 1926–1986), Willis (1928–2008), and Jake Jr. (1931–?). Joseph and his brothers David (1989–2016) and Adam Hutton (b. 1991) grew up on the island. Joseph attended first through eighth grades on Daufuskie and went on to Hilton Head High School; he graduated from Clemson with a degree in forestry and earned a master's degree from the University of Maine. (Martha Hutton.)

Brandy Bartlett (b. 1986) and Albertha Robinson Stafford hold hands in front of the First Union African Baptist Church on Easter Sunday in 1988. Brandy's family moved to Daufuskie when she was one month old and lived on their sailboat at Freeport Marina until they barged a mobile home to the island. Her mother, Meg, ran the general store, drove the school bus, and was a substitute teacher at the Mary Field School. Brandy's father, James, built several houses and the Sportsman's Lodge at Melrose. The Bartlett family moved to Hilton Head in 1990 when their daughter Jamie was six months old. (Meg Bartlett and Wick Scurry.)

In 1985, Geraldine Ward Wheelihan (1922–2004) and her son, Gerald Yarborough, herd their cows with a motorcycle and a three-wheeler used for UPS deliveries. Cows roamed free but needed to be tied up or fenced in when golf courses were built at Haig Point and Melrose and by March 15 each year, when neighbors planted their gardens. Without enough land to graze their cattle, Yarborough regularly hauled 50 bales of hay and 300 pounds of sweet feed to the island on two small speedboats. (Martha Hutton.)

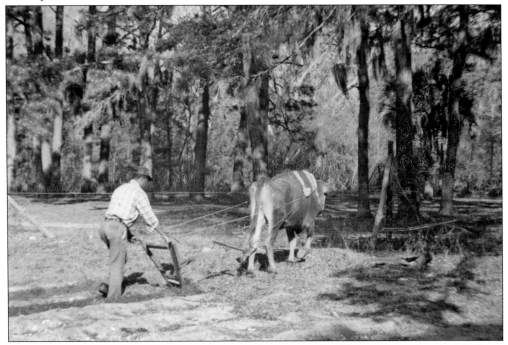

Willis Simmons Sr. was a boat captain, hunter, fisherman, and crabber. He served in the US Army and was employed by Beaufort County Public Works maintaining Daufuskie's dirt roads. He is shown here plowing his garden in 1985. Simmons was the son of Jake and Lillie Simmons and had a family of his own with Janie Wiley Simmons (1932–2017), his wife of 56 years. (Martha Hutton.)

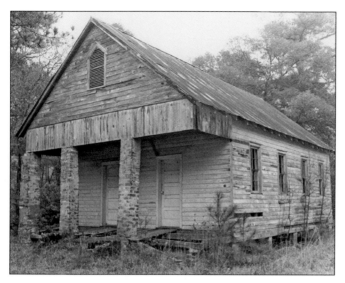

The construction of Mount Carmel Baptist Church No. 2 was led by island carpenter, general store owner, and WPA worker Samuel Holmes (1891–1969) in 1941, a year after a hurricane destroyed the church built in 1901. The land was owned by Paris Holmes (b. 1843) in the early 1880s; a one-fourth-acre portion was sold to church members by his widow, Mary G. Holmes (b. 1867). The building was restored by the Daufuskie Island Historical Foundation and is now a museum. (Beth Finnegan.)

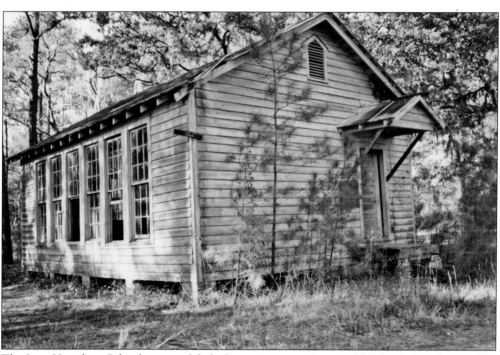

The Jane Hamilton School was modeled after a one-room Rosenwald School plan designed by architect Robert Robinson Taylor for Booker T. Washington of the Tuskegee Institute and Julius Rosenwald of Sears, Roebuck & Company. Jane Hamilton deeded one fourth of an acre of land to the Beaufort County Board of Education for a new school for black students on the north end of the island built by Works Progress Administration employees and volunteers. Owned by Beaufort County, the school building has been restored by the Daufuskie Island Historical Foundation as a library and museum. (Beth Finnegan.)

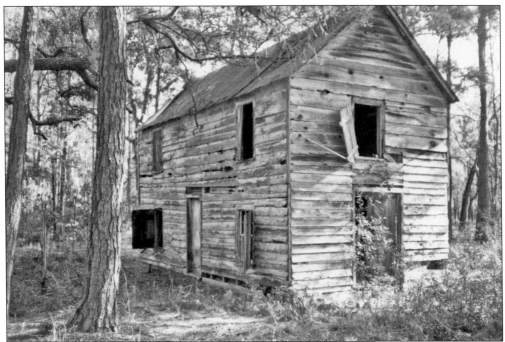

The Union Brothers & Sisters Oyster Society, organized in 1919, purchased the Chaplin family's home at Benjie's Point in 1921 for their meeting hall. The building was disassembled and moved inland to what is now Hinson White Road. Members held monthly meetings and collected dues to help with the financial needs of oyster workers and their families. In 1920, John O. Daniels of Jamaica lived in the building and ran a private school where he taught members of the Bentley, Bryan, Gordon, Hudson, Jones, Whaley, and Williams families. The society sold the property in 1981. Now owned by the Daufuskie Island Historical Foundation, the building was restored in 2012. (Beth Finnegan.)

The Daufuskie School was built for white students in 1913. Today, the building holds the archives of the Daufuskie Island Historical Foundation. Much of the collection was donated by former postmaster Billie Burn, who, with a significant contribution by Rebecca Starr, wrote a detailed history called *An Island Named Daufuskie* (1991). In 1985, Miss Billie published a cookbook based on local recipes. (Beth Finnegan.)

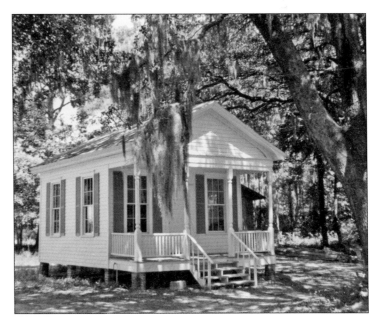

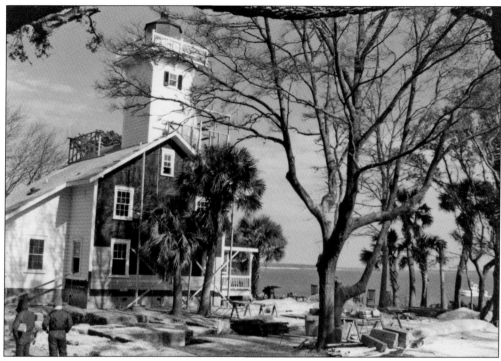

In 1985, archaeologist Larry Lepionka and architect and tabby expert Colin Brooker were hired by International Paper Real Estate Corporation of South Carolina to conduct a pre-development survey that included a search for prehistoric sites and the whereabouts of the original Haig Point plantation house. After studying and mapping the remains of two rows of tabby slave cabins built from 1820 through 1850, they discovered the foundation for the main house, built around 1829, located beneath the 1873 Haig Point lighthouse. (Larry Lepionka.)

Continuing their archaeological investigation, Larry Lepionka (right, with Michael Posey) and his team dug test trenches around the footprint of the plantation house. After excavating the entire foundation, they found the full extent of the residence. Wooden planks were found on the raised basement floor as well as a burn layer that may have dated from 1861–1863 when the property was occupied by Union troops. Materials from the house may have been used to build docks on the Cooper River and the New River or for tracks made with planks to cart sandbags and carry 10,000 Daufuskie tree trunks through the marsh at Jones Island in the Savannah River, where a six-cannon battery was erected in 1862. (Larry Lepionka.)

An array of artifacts was discovered during the archaeological study at Haig Point, including pieces of ceramic pipe from Scotland, buttons, buckles, pottery, kitchen utensils, dish fragments, pitchers, and jugs. One 4.5-inch hand-blown blue-tinted glass bottle with raised lettering reads: "GENUINE ESSENCE." It likely contained essence of peppermint from Frederick Klett & Company of Philadelphia, which manufactured the elixir from 1843 until 1858. Many of the found objects are on display at the Strachan mansion at Haig Point. (Larry Lepionka).

Found at the Haig Point cemetery, this clock housing was carefully photographed, catalogued, and returned to its original location during the archaeological survey. Glass bottles, pitchers, perfume bottles, medicine bottles, jugs, bowls, basins, and other personal household items were found on the gravesites. "Grave goods" were chosen based on burial practices maintained by the descendants of enslaved Africans. There are eight cemeteries on Daufuskie Island: Haig Point, Bloody Point, Mary Dunn, Fripp, Webb, Cooper River, Maryfield, and the burial ground at the First Union African Baptist Church. All but the Fripp and Webb Cemeteries are in use today. (Larry Lepionka.)

Sitting on the porch from left to right are Salvatore "Sal" Strozzi (1925–1999), Steven Lowry, James Bartlett, and Wade Hampton "Hampy" Sloman. Strozzi, a self-taught carpenter, gathered cedar wood to make countertops, tables, plant stands, and step stools; he built his house from trailer parts and wood salvaged from other homes. In 1995, when Beaufort County announced that motor-vehicle laws would be enforced on Daufuskie, Strozzi, who arrived on the island in the early 1980s, abandoned his 1978 Oldsmobile station wagon with a Florida license plate a decade out of date. (Tucker Bates.)

Ruby "Miss Shorty" Whittington Smith (1917–2015) shares a bench with "Sier" Simmons. She had three sons, James, Norman, and Leonard, and lived on Daufuskie with her husband, Ben H. Smith (1913–1982), who worked for the telephone company. The Smiths lived on the Cooper River in a mobile home with a dock nearby. Miss Shorty drove the Mary Field School bus from 1983 until 1987. Her son, Leonard "Sonny" Smith (1940–1993), a US Navy veteran, built an A-frame house on the island out of telephone poles not far from Jolly Shores. (Martha Hutton.)

Walter "Bubba" Simmons Jr. (1923–2002) was born and raised on Daufuskie. His parents were Walter and Agnes Mitchell Simmons. Simmons served in the US Army, then moved to New York. Returning to the island, he married Linda Hamilton and with their daughter Pamela Simmons, the family owned and operated a restaurant called Simmons' Place on Benjie's Point Road. Lucy Bell's Cafe opened in the same location in 2016. (Martha Hutton.)

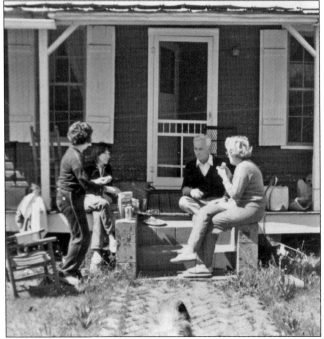

In 1980, after their honeymoon in New Orleans, Woody and Lynn Collins (and their dog, Little Eli) rented this house next to the Daufuskie School from the Simmons family. Lynn Collins (right) is seen here with friends and family on their porch. While laying down a brick walkway and painting the trim, Woody Collins found a 1919 penny under the door frame, likely signaling the date that the house was built. A shrimper, Collins sold his catch off the dock at Palmetto Bay Marina on Hilton Head, then opened Captain Woody's Bar and Grill in 1982. On his last drag of the season, Collins was known to offer his haul free-of-charge to Daufuskie residents. (Woody Collins.)

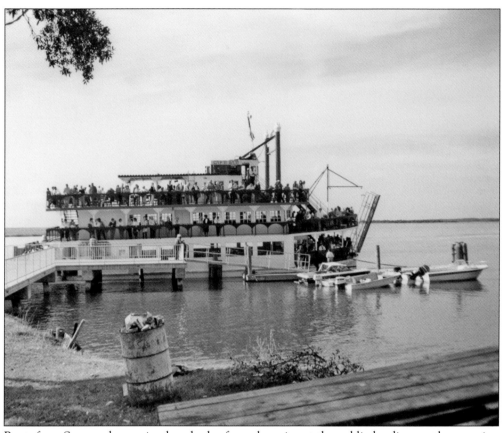

Boats from Savannah carrying hundreds of people arrive at the public landing on the morning of Daufuskie Day. The ride from Savannah takes more than the usual hour as the boats are filled to capacity and must travel slowly, leaving plenty of time for card games and conversation. This annual event held on the fourth Saturday in June was initiated by Frances Jones in 1976 to celebrate Daufuskie Island traditions, culture, and community and as a homecoming for family and friends. The date was chosen to coincide with the June 27 anniversary of the dedication of the First Union African Baptist Church. Daufuskie Day provides an opportunity for many generations to reminisce and make plans for the future. This ticket from 1985 was for the round-trip on the *Waving Girl*. (Above, Martha Hutton; below, Daufuskie Island Historical Foundation.)

DAUFUSKIE DAY on the WAVING GIRL N⁰ 156

DAUFUSKIE DAY CRUISE

June 22, 1985

On Cap'n Sam's WAVING GIRL

Departs at 9:00 a.m. From River Street Dock, Returns at 6:00 p.m.

N⁰ 156

Adults $12.00

Daufuskie Day would not be complete without line dances like the Bus Stop, the Wobble, the Cupid Shuffle, and the Electric Slide. Tents are set up along the waterfront with vendors selling crafts and food: barbecue, deviled crab, boiled shrimp, fried chicken, fried turkey legs, boiled peanuts, potato salad, sweet tea, and sometimes, homemade wine. Daufuskie Day is now coordinated by the Daufuskie Island Foundation; a history board is set up for families to post pictures of loved ones, island tours are offered, and tee shirts are sold to raise funds for the following year's event. (Sallie Ann Robinson.)

This group is being driven to the Mary Dunn Cemetery in April 1983 for the unveiling of a marker commemorating the Martinangele family. The sign reads, in part, "Philip Martinangele, born in Italy, immigrated to this country and settled in St. Helena's Parish. He married Mary Foster in 1743 but had died by 1762, when his widow bought 500 acres on Daufuskie Island. In December 1781 . . . their son Philip, a captain in the British Royal Militia, was killed by . . . a partisan band of Hilton Head Island. He is probably buried here with others of his family." The marker was erected by the Hilton Head Island Historical Society. (Daufuskie Island Historical Foundation.)

THE DAUFUSKIE KIDS' MAGAZINE

A collection of writing, poetry and artwork by the students
at Mary Fields Elementary School on Daufuskie Island, S C

The first of four editions of the *Daufuskie Kids' Magazine* was published in 1981. At the urging of Pamela Tarchinski of the South Carolina Arts Commission, and with a grant from the National Endowment for the Arts, Shannon Wilkinson, a freelance writer from Hilton Head, spent two weeks on Daufuskie as an artist-in-residence at the Mary Field School. Working with 11 students and teachers James and Carol Alberto, Wilkinson's sojourn led to the production of a magazine filled with creative writing and artwork intended to help students learn more about themselves and allow readers to learn more about the island. Proceeds went to a scholarship fund "applicable toward post high school education and training for present and succeeding pupils." Photographs for the first edition were taken by Victoria Darlington. (South Carolina State Library.)

Christina Roth Bates, seen here with her son Tucker, moved to Daufuskie in 1982 and is among the artists who have found inspiration on the island. Her etchings of historic Daufuskie scenes are prized by collectors; Sally Lesesne utilizes paint and pencils to capture playful and serene island moments; and Chase Allen of Iron Fish Gallery crafts coastal-inspired metal sculpture. Authors Roger Pinckney XI and Bo Bryan explore Lowcountry themes in their writing, and Lancy and Emily Burn of Silver Dew Pottery add a pinch of Daufuskie sand to each of their pieces. (Tucker Bates.)

Tucker and Taylor Bates were given a motorized Jeep for Christmas that they drove along the Bloody Point beach with their mother, Christina, who rode a four-wheeler, and their father, Bud, on his motorcycle in 1989. Though motor vehicles are no longer allowed on the shoreline, Daufuskie is one of only a few places in the country where horses can be ridden on the beach, along the Calibogue Sound and the Atlantic Ocean. (Tucker Bates.)

Christina Roth Bates rides with her horse Calibogue to Daufuskie Island from Broad Creek Marina on Hilton Head. After the landing craft she had arranged for never arrived, an old wooden raft was fashioned with railings and stacked hay bales to keep the horse contained. The makeshift barge pulled by her husband Bud's shrimp boat drew a crowd of curious boaters. Agitated by the spectators and rough water, Calibogue broke loose when they neared the Haig Point dock, jumped into the water, raced up the bank, and disappeared into the woods. The horse was found two days later unharmed. (Christina Roth Bates.)

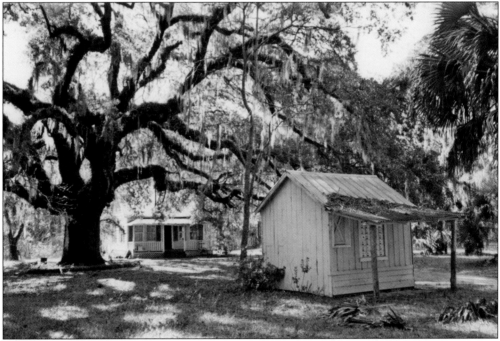

Bud Bates opened a real estate office in the former home of Daufuskie undertaker and church deacon Moses Ficklin in 1981. The shed out front, that had been used to store caskets, was converted to house post office boxes when his wife, Christina Roth Bates, was postmaster in the mid-1980s. Their horse Calibogue was pastured in a field across the road. The Bateses renovated the 1925 house, adding hardwood floors and a sleeping loft. The family of four lived there for several years until they built a new house on the Cooper River. (Tucker Bates.)

Lancy (b. 1938) and Emily (b. 1941) Burn built boats, hand-knotted cast nets, crafted sails and oars, and fished for a living. Married in 1974, the Burns lived on their 28-foot sailboat, owned 20 acres of land, and built a three-story A-frame house in 1976. They kept bees for honey and grew their own vegetables, with Lancy Burn hunting for deer and rabbit. Today, they operate the Silver Dew Pottery in a studio by the A-frame and live in an energy-efficient home with a pond for fish, fruit and olive trees, bees, chickens, and an extensive garden. (Lancy and Emily Burn.)

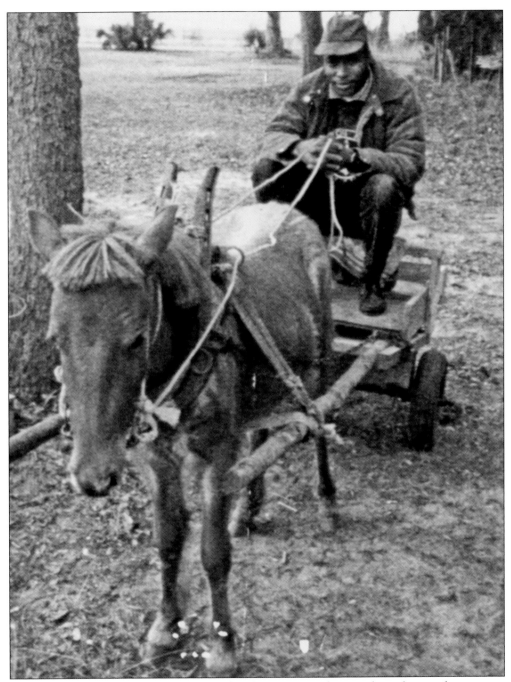

With a harness and staves cobbled together from an ox yoke, tree branches, and strapping, Carvin Robinson (1956–1994) trained this Marsh Tacky to pull a wagon. Robinson, son of Lucille Robinson Smith, was a commissioner of the Daufuskie Island Fire Department and a jack-of-all-trades. Marsh Tackies are the descendants of Spanish horses brought to the sea islands in the 1500s. They adapted well to the salt-marsh terrain and were invaluable for transportation and as working partners in the fields. The Daufuskie Marsh Tacky Society promotes the breed, now the state heritage horse of South Carolina. (Meg Bartlett and Wick Scurry.)

Having lived on both Bull and Hilton Head Islands, John (1888–1944) and Lula Stafford (1892–1964) moved to Daufuskie in 1936 with their children Thomas, Michael, Flossie, Herbert, and Johnny. They lived at the end of what is now called Carvin Road near the Cooper River. Their house had two bedrooms, a living room, dining room, and a kitchen with a wood stove. There was a hand pump for water and an outhouse in the five-acre yard. For bathing, water was heated on the stove and poured into a cast-iron claw-foot tub. (Daufuskie Island Historical Foundation.)

The oil house, where the lamp for the Bloody Point Rear Range was stored, was built with 6,000 bricks in 1883 and became the Silver Dew Winery in 1953. Arthur "Papy" Ashley Burn Jr. and his fourth wife, Addie, sold wine made from fresh-picked berries and other island fruits. Burn experimented with many flavors, including once, remembers Gerald Yarborough, a ten-gallon batch of "rotten orange wine" made from already-fermenting oranges bought from a Savannah grocer. This photograph was taken on a rare snowy Christmas Day in 1989. Today, the building is part of the Bloody Point Lighthouse & Museum. (Daufuskie Island Historical Foundation.)

Real estate developer Charles Cauthen, seen here in the mid-1980s, was charmed by Daufuskie Island during his first visit in 1972: "They were singing and dancing at Cap'n Sam's. I ate deviled crab so thick and tasty it made you smack your lips. I strolled down a road into a deep jungle that felt magical." With the Daufuskie Island Land Trust, Cauthen purchased Haig Point from the Bostwick family in 1979. In 1980, he brokered a deal on the Webb Tract and purchased Oak Ridge with the Plantation Land Company. In 1984, the Webb Tract was sold to the Plantation Land Company and Haig Point Plantation was sold to International Paper Realty Corporation. It was Cauthen's idea to keep Haig Point car-free. (Martha Hutton.)

Plans for the Melrose development included the Melrose Inn facing the Atlantic Ocean (the framing for which is seen here), a conference center, a pool and restaurant complex, an equestrian center, residential lots, beach villas, staff housing, and a 150-acre Jack Nicklaus–designed golf course. Nicklaus later said, "Melrose was a gorgeous piece of property, an uncut jewel. There's oceanfront, salt and fresh marsh, live oaks, mature pines and magnolias. All we had to do was set a golf course in there." (Martha Hutton.)

James Coleman, Stephen Kiser, and Robert Kolb of the Melrose Company purchased the 740-acre Melrose Plantation in 1984 from the Bluffton Timber and Land Company, whose owners included Charles Fraser and Joseph Harrison. The Stoddards had sold the property to the Bluffton Timber and Land Company in 1971; it was the last of the family's holdings on Daufuskie Island. Melrose Landing on the Cooper River was initially part of the Scurry family retreat. The Melrose Company purchased the dock and parking area in the early 1990s when they needed boat access to the island for the Melrose and Bloody Point developments. (Both, Martha Hutton.)

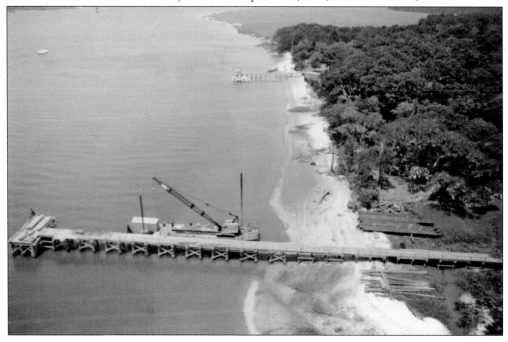

The first traffic signs were installed on Daufuskie Island in 1986, including a stop sign, a yield sign, and a school-crossing sign. The first roads to be paved on Daufuskie were at Haig Point in 1985. The public road that runs from the north to the south end of the island, originally built in 1805, was paved in 1996. Edward Boys, Daufuskie Island's fire chief, was instrumental in naming the roads on Daufuskie, with many honoring longtime residents who had lived there. (Martha Hutton.)

The abandoned pay phone pictured here in the late 1980s was installed near the public landing in 1972. The Hargray Telephone Company had been given the right to install phone service in 1954 but was slow to follow through. In December 1972, approximately 85 Daufuskie Island residents traveled to Columbia, South Carolina, to attend a meeting of the Public Service Commission, supporting Joseph Limerick of Coastal Carolina Utilities, who had been providing phone service on the island. The Hargray Telephone Company ultimately won the contract to install a microwave transmission system that went into service in June 1973. (Martha Hutton.)

Scotsman Frank Duncan McPherson Strachan Sr. (b. 1871) of the Strachan Shipping Company built Beach Lawn on Retreat Plantation in 1910 on St. Simons Island, Georgia. The house was sold to US Congressman William Stuckey Jr. (Stuckey's pecan products and gift shops) in 1966, then to Joseph Edwards of the Edwards Baking Company in 1976. In 1986, the 7,500-square-foot, three-story home was purchased for $1 by the International Paper Realty Company. Winched off the beach and barged over 100 miles to Daufuskie Island, the trip was timed with the tides to float the house under multiple bridges. Today, the mansion houses Haig Point's post office, general store, a bar, and four guest rooms. (Woody Collins.)

Gerald Yarborough heard the story of his birth from midwife Sarah Hudson Grant: "Son, your grandma [Gillian Ward White, 1900–2000] ran to my house and said, 'Hurry, Geraldine is about to deliver!' With a handful of lard, you popped right out!" Growing up hunting squirrels, he often shared his quarry with "Aunt Sarah," who once gave him a pint of homemade wine in exchange and said, "Don't tell your mama." After serving with the US Army in Vietnam, Yarborough worked as an EMT and at Haig Point. (Haig Point.)

Six

1990s

During the early 1990s, media coverage of real estate development on Daufuskie and throughout the Sunbelt raised concerns about increasing property taxes from significantly higher land values. The Christic Institute South (later called the Southern Justice Institute) filed a suit on behalf of a group of Daufuskie's black residents against developers for "trespass and desecration of a cemetery." The issue was ultimately resolved by moving the Melrose Company's cottage-style reception center farther away from the historic Cooper River Cemetery and contributing land to create a buffer around the burial ground.

In 1992, the National Association for the Advancement of Colored People (NAACP) pursued claims regarding the island's "uneven tax structure, land seizures and inadequate public services." Many properties on Daufuskie were eligible for a state-provided agricultural tax exemption, but a number of owners, predominantly black, were either unaware or distrustful of the opportunity that would have significantly lowered their liabilities. As a result, most eligible properties have since been reclassified. In 1994, the NAACP announced plans to develop a "Daufuskie Village" that would include an inn and conference center to create jobs for black residents but the project was never realized.

Daufuskie's infrastructure continued to improve in 1991, with 31,500 feet of underwater cable installed from the mainland to increase electric capacity to the island. In 1995, Beaufort County began enforcing motor-vehicle laws including mandatory car registration and drivers' licenses. In 1996, the first road outside of the developments was paved.

The Daufuskie Island Elementary School was built in 1995 at the north end of the island, replacing the Mary Field School; the final graduation from the 60-year-old school took place in June 1995. Now owned by the First Union African Baptist Church, the Mary Field School houses a community meeting space, indigo artisans Daufuskie Blues, and School Grounds Coffee shop.

The planned-unit developments (PUDs) at Bloody Point, Melrose, and Haig Point continued to grow throughout the 1990s; each one operated with a unique set of rules and regulations for property owners. For the first time in the history of the island, the white population exceeded the black population.

With quiet self-sufficiency, longtime island residents continued to live in the Historic District. Throughout the island, residents were conscious of the impact of development on cultural identity and the need for environmental and historic preservation.

Ned Lesesne Freeman moved to Daufuskie in 1992 when he was nine years old. At the Mary Field School, his teacher was Catherine Bates Campbell. At that time, the school had a very high ratio of computers to students, and Miss Catherine encouraged the students to use the computers after they finished their schoolwork. Motivated students worked quickly and efficiently, and Ned developed particularly strong computer skills. His rooster often accompanied him down Hinson White Road on his way to school and chased after the school bus, driven by Sallie Ann Robinson, as it drove away. (Sally Lesesne.)

On a trip to Harbour Town on Hilton Head, Tucker Bates feeds a dolphin off the side of his family's boat. His father, Bud Bates, threw his cast net to catch bait fish to feed them. Passengers on cruise ships that frequented the area often fed the dolphins, making the animals accustomed to human interaction. In 1994, just a few years after this photograph was taken, the Marine Mammal Protection Act was amended to make the feeding of wild dolphins illegal, with a maximum civil penalty of $10,000, a maximum criminal penalty of $20,000, and one year in jail. (Christina Roth Bates.)

Bud Bates throws a cast net off the dock at Freeport Marina. To attract shrimp, he made "shrimp balls" with cat food and mud. After drying in the sun, the home-made, patty-shaped bait was tossed into the water, sinking to the bottom. As the balls broke up, the shrimp swarmed, making them easy to catch. Today, shrimp baiting requires a license and shrimp balls are made from fish meal, clay, and all-purpose flour. (Tucker Bates.)

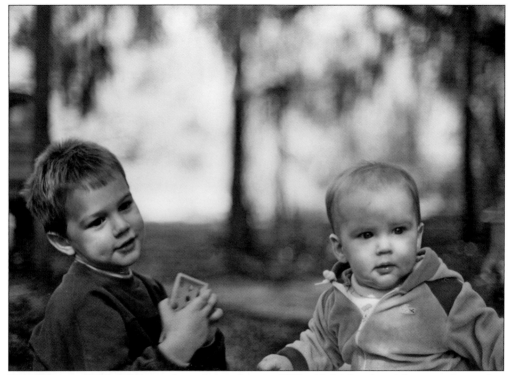

David Hutton (1989–2016), age three, is seen here in 1992 with his brother Adam, ninth months. They grew up on Daufuskie Island with their older brother, Joseph, and parents, Christopher and Martha. For the Hutton boys, Daufuskie was one big backyard where they fished, camped, swam, biked, and hunted. They knew every inch of the island. David played football at Hilton Head High School and was homecoming king. Roger Pinckney XI said of David, a born leader, "He led by example. I never heard him say a bad thing about anyone." (Martha Hutton.)

Having grown up in Beaufort, Roger Pinckney XI first visited Daufuskie Island as a young man with his father. Roger Pinckney X built the wooden dock at the public landing, helped hang the first electrical wires from the mainland, and worked as the Beaufort County coroner for 35 years, following in the footsteps of his father, Roger Pinckney IX. Pinckney XI is a novelist, essayist, avid hunter, explorer, and island guide who has made Daufuskie his home since the late 1990s. (Sally Lesesne.)

The Daufuskie Fire District was established in 1988 as an all-volunteer fire department with Richard Perkins as fire chief. The Daufuskie School (closed in 1962) was used as the headquarters. After the district was chartered in 1989, Christopher Joseph Hutton (1952–2014), seen here on July 4, 1993, became the first paid fire chief in 1991 with board commissioners John Kowalski, Bud Bates, and Wick Scurry. Edward Boys joined the Haig Point Fire Department in 1988 and today is the chief of the Daufuskie Island Fire Department. The fire station was built in 1998, with a landing area for helicopter evacuations nearby. (Martha Hutton.)

William "Wick" Porter Scurry was in the marine-transportation business and wanted to build a marina on his family's riverfront property on Daufuskie. His initial plan was for a day dock to supply fuel to boats on the Intracoastal Waterway and offer a place for islanders to sell deviled crab to tourists at the Cooper River Landing. After the property was sold to the Melrose Company, Scurry built Freeport, a full-service marina with an expansive dock, boat storage, general store, rental cabins, ferry service, tours, and the Old Daufuskie Crab Company restaurant. (Wick Scurry.)

Actor and director Clint Eastwood (not pictured), members of his family, and actor John Cusack took the *Freeport Shuttle* to Daufuskie Island from Savannah for Eastwood's 67th birthday dinner, hosted by Wick Scurry in May 1997. Marshside Mama's Beth Shipman cooked for the group, which was in Savannah for the filming of *Midnight in the Garden of Good and Evil*. The *Freeport Shuttle*, previously a charter fishing boat, transported island residents to and from Broad Creek Marina on Hilton Head as part of the Daufuskie Island public transportation contract with Beaufort County. (Christina Roth Bates.)

The Melrose Company purchased Bloody Point, seen here, and the Eigelberger Tract (more than 600 acres total) in 1988 from the estate of Morton Deutsch, of Savannah. The initial plan for the private, oceanfront Daufuskie Island Club offered 550 memberships intended for vacation use, not as primary residences; 99 single-family dwellings; guest cottages; two beach clubs; tennis courts; and a clubhouse and golf course designed by Tom Weiskopf and Jay Morrish that opened in 1991. (Michael and Joanne Loftus.)

The southern tip of Daufuskie was first referred to as Bloody Point after a violent clash in January 1728 between the Yamassee Indians and British forces. Already embattled for decades over colonization efforts, the Daufuskie Fight during the 1715 Yamassee War was well documented. The Yamassee, in canoes, were gunned down by soldiers lying in wait in the brush. Today, there is no trace of those historic conflicts. No longer allowed on the beach, golf carts are the most common mode of transportation. (Michael and Joanne Loftus.)

Haig Point is a 1,100-acre private member–owned community that includes 29 holes of golf designed by Rees Jones, a clubhouse, two restaurants, tennis courts, a beach club, a fitness room, pools, a beach trail, equestrian center, the historic lighthouse, and more than 500 homesites. The land was purchased in 1984 by the International Paper Realty Corporation and opened in 1986. Ownership of the property was turned over to the members in 2001. Today, almost 300 houses have been built, with 100 serving as primary residences. Haig Point residents travel throughout the community and across the island using electric golf carts. (Haig Point.)

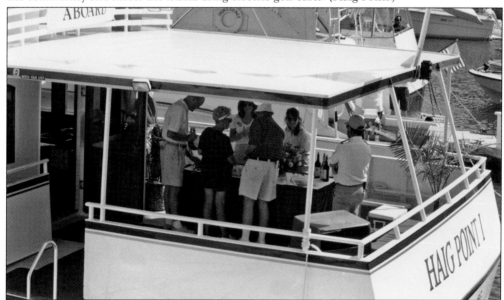

The Haig Point Ferry Company operates with eight vessels including the *Haig Point I* and *II* (holding 86 passengers each), the *Haig Point III* (30 passengers), the *Haig Point IV* (100 passengers), the *Palmetto Merchant* (49 passengers), the *Pelican* (40 passengers), and two water taxis. The membership also owns a 13-acre parcel on Hilton Head Island with a welcome center and ferry embarkation. The Haig Point dock on Daufuskie is located by the Strachan mansion at the northern tip of the island bounded by the Cooper River to the west and the Calibogue Sound to the east. The ride from Hilton Head to Haig Point is 30 minutes. (Haig Point.)

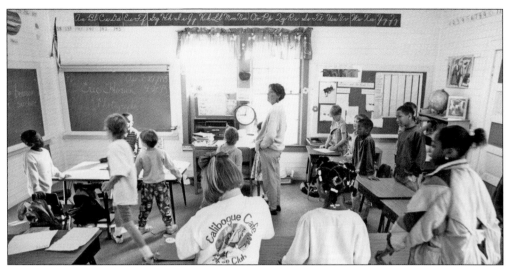

Catherine Bates Campbell moved to Daufuskie in 1987 when a teaching job became available at the Mary Field School. She and her daughter Grayson, a middle schooler, lived on the school grounds in a trailer provided by the Beaufort County School District. Starting in 1983, middle school and high school students were taken by boat then bus for school on Hilton Head on Mondays with a return trip on Fridays. Weeknight housing was arranged with a stipend paid by the school district. Campbell was instrumental in obtaining government funding for daily round-trips for Daufuskie Island students beginning in 1987. (Catherine Campbell, photograph © Eric Horan.)

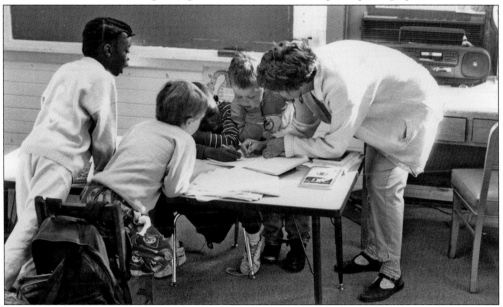

Catherine Campbell was chosen as one of 5,500 "community heroes" to carry the Olympic torch in Columbia, South Carolina, prior to the 1996 Olympic Games in Atlanta, Georgia. She was nominated by her sister-in-law Christina Roth Bates for her efforts on behalf of the children of Daufuskie. Campbell was joined by her students and fellow teacher Michael Miller as she trained on Daufuskie's sandy roads. On June 26, 1996, a large group of island residents traveled to the state capital to cheer her on. Miss Catherine is seen here with some of her students, including Pamela Simmons (left). (Catherine Campbell, photograph © Eric Horan.)

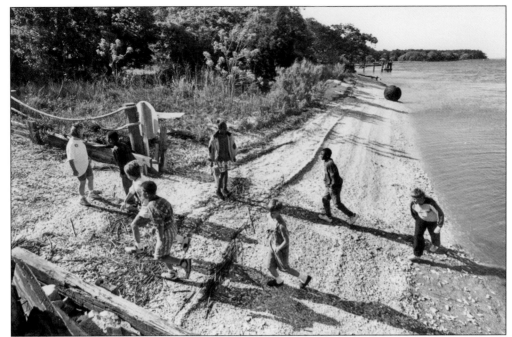

Eric Horan, a commercial photographer and wildlife photography guide, visited Mary Field School to take pictures for the third edition of the *Daufuskie Kids' Magazine* in 1993. For students on Daufuskie, the island is their classroom: the woods, the salt marsh, the dunes, and the beach. On- and off-island field trips are highlights of the year. On a trip to the Kennedy Space Center and Disney World in Florida, Catherine Campbell realized that many of her students could not swim. When they returned, she helped convince Melrose to offer swimming lessons at their pool. They visited the Coca-Cola Museum in Atlanta and traveled on the Blue Ridge Parkway in North Carolina. Miss Catherine recalled that for her students, "seeing the mountains was like a fantasy." (Both, Catherine Campbell, photograph © Eric Horan.)

Seven

2000s

Daufuskie offers a range of lifestyles for its more than 400 full-time and as many part-time residents, and provides a variety of attractions for visitors. Institutions have been established to protect and enhance the island. The Daufuskie Island Historical Foundation, founded in 2001, promotes the island's cultural heritage with museums, tours, educational programs, archives, and the restoration of historic structures. The Daufuskie Island Foundation, founded in 2004, addresses issues of concern to native islanders and provides opportunities for community gatherings. The Daufuskie Island Conservancy, founded in 2005, provides educational programs and encourages stewardship and preservation of the island's natural resources. The Daufuskie Island Community Farm, founded in 2009, grows food, raises animals, and mills lumber onsite. The nine-member Daufuskie Island Council, formed in 2010, acts as a liaison between residents and Beaufort County. The Daufuskie Marsh Tacky Society, founded in 2015, advocates for the heritage breed. All of these organizations are volunteer-driven.

On Daufuskie, photographers have captured moments in time; songs, poems, and novels have been written; and island news has been reported in all forms of media. Maps have been charted, demographics have been surveyed, and natural resources have been utilized or even exploited. Sunbelt developers discovered Daufuskie, but some were daunted by the lack of commercial-scale infrastructure and island logistics. Some plans have succeeded, some have failed.

Many things have stayed the same: Daufuskie deviled crab is a delicacy, cast nets are the best way to catch shrimp, one can fish for dinner, many roads remain unpaved, and it takes a boat to get there. The pace of living on the island is satisfyingly slow, but with time comes innovation. The ox-cart gave way to golf carts and cars while motor boats replaced hand-made bateaux. For some, the telephone and television led to the decline of face-to-face conversation and storytelling, and the convenience of electricity made wood and kerosene for heating, lighting, and cooking virtually obsolete.

Island resident John Mellencamp said it best: "Once you get on Daufuskie you get on Daufuskie time. . . . On Daufuskie Island, only the sun matters. The sun's not gonna lie to you—it's gonna come up, and it's gonna go down. The rest of the time, it doesn't matter what time it is. . . . Because you actually are able to go to Daufuskie and live, not on somebody else's time, not on the man's time, not on the boss' time, but on your time. And you just create your own world."

Daufuskie has to be experienced to be understood.

In 2006, photographer Pete Marovich visited Daufuskie to visually document the influence of development on the island's landscape and culture. The Daufuskie School, owned by the Beaufort County School District, closed in 1962. Currently leased by the Daufuskie Island Historical Foundation, the building once housed the island's community library. (Pete Marovich/American Reportage.)

Daufuskie, with only 600 homes, lies across the Calibogue Sound from Hilton Head's Harbour Town. For decades, the brackish waters and highly productive yet fragile salt marsh were essential to the island's economic prosperity. Today, nature and animal life abound with horseshoe and hermit crabs on the beach, bald eagle nests high up in the pine trees, a rookery with herons, egrets, and wood storks, alligators prowling in the golf course lagoons, and dolphins and American oystercatchers along the shore. (Pete Marovich/American Reportage.)

Daufuskie Island Elementary School opened in 1995. Fabricated in Greenville, the new school building was brought by barge in sections and assembled on property owned by Beaufort County on Old Haig Point Road. Teachers Catherine Campbell and Michael Miller organized a farewell celebration including one final maypole dance at the 60-year-old Mary Field School that became the property of the First Union African Baptist Church. (Above, Pete Marovich/American Reportage; below, Amanda Lofton.)

Flossie Stafford Washington (1926–2014) came to Daufuskie Island when she was 10 years old with her family, having lived across the water on Bull Island. Seen here in 2006, she attended the Cooper River and Jane Hamilton Schools. With her husband, Jake Washington, she had 15 children, 24 grandchildren, 44 great-grandchildren, and 11 great-great-grandchildren. Miss Flossie worked for the Southeastern Shipbuilding Corporation in Savannah during World War II. She was an assistant to midwife Sarah Hudson Grant and was employed as a custodian at the Mary Field School in 1967. Her daughter Margarite Washington remembers her mother telling her children, "Every day is not going to be sunshine, but make the best of it." (Pete Marovich/American Reportage.)

The First Union African Baptist Church has been open almost every Sunday for more than 130 years. As a place to gather, the church has held worship services, children's programs, weddings, funerals, and for 50 years, the Savannah River Baptist Association vacation bible school. The building has retained its integrity and identity. Open to the public as a historic site, visitors marvel at its serenity. Stepping inside is like taking a step back in time. (Pete Marovich/American Reportage.)

Aubrey Lofton, seen here in 2003, grew up on Daufuskie and attended the Daufuskie Island Elementary School. She volunteered at the Daufuskie Community Farm and has developed the independent spirit that all children on the island seem to possess. Commuting daily by boat and bus to middle school and high school in Hilton Head, Aubrey is a member of the US Army Junior Reserve Officers' Training Corps and works at the Freeport General Store and the Old Daufuskie Crab Company. Growing up in a small community, on a small island, the world is her oyster. (Sally Lesesne.)

DISCOVER THOUSANDS OF LOCAL HISTORY BOOKS FEATURING MILLIONS OF VINTAGE IMAGES

Arcadia Publishing, the leading local history publisher in the United States, is committed to making history accessible and meaningful through publishing books that celebrate and preserve the heritage of America's people and places.

Find more books like this at
www.arcadiapublishing.com

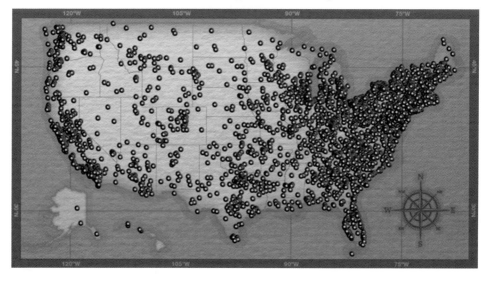

Search for your hometown history, your old stomping grounds, and even your favorite sports team.

Consistent with our mission to preserve history on a local level, this book was printed in South Carolina on American-made paper and manufactured entirely in the United States. Products carrying the accredited Forest Stewardship Council (FSC) label are printed on 100 percent FSC-certified paper.

MADE IN THE
USA